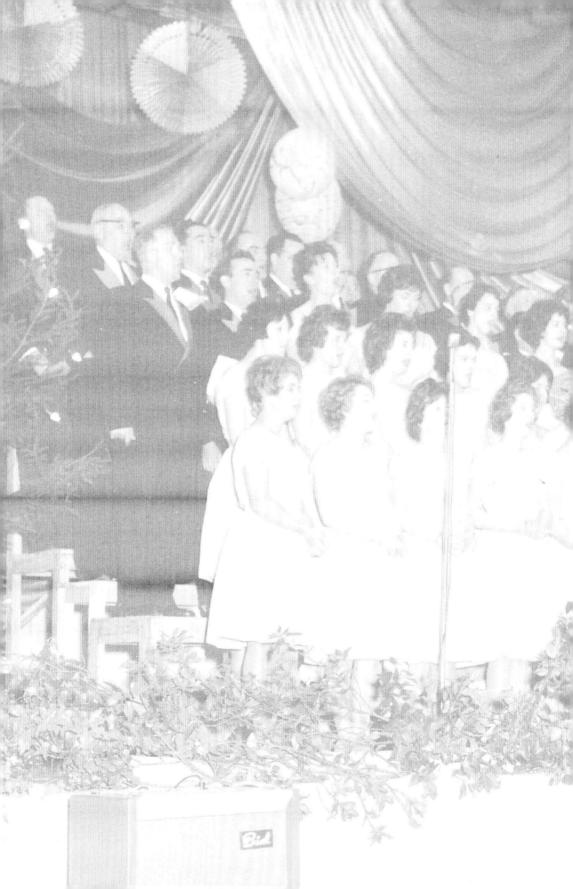

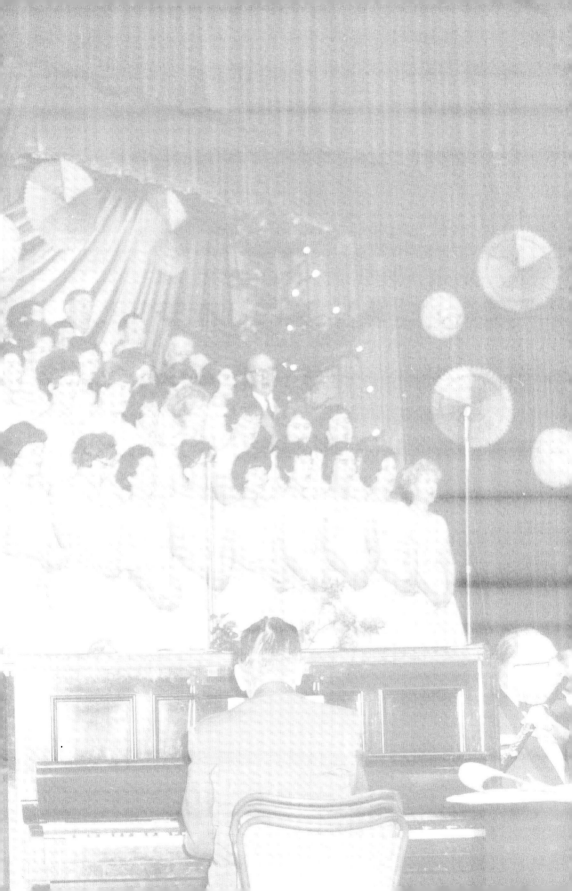

LUTON
PAST & PRESENT

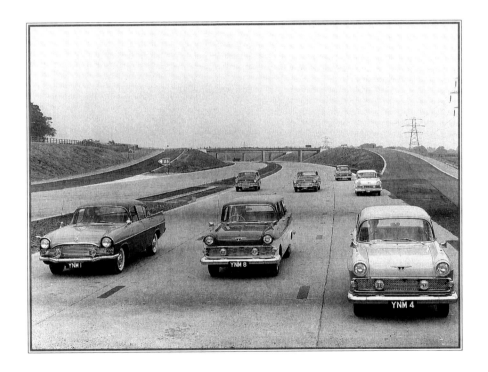

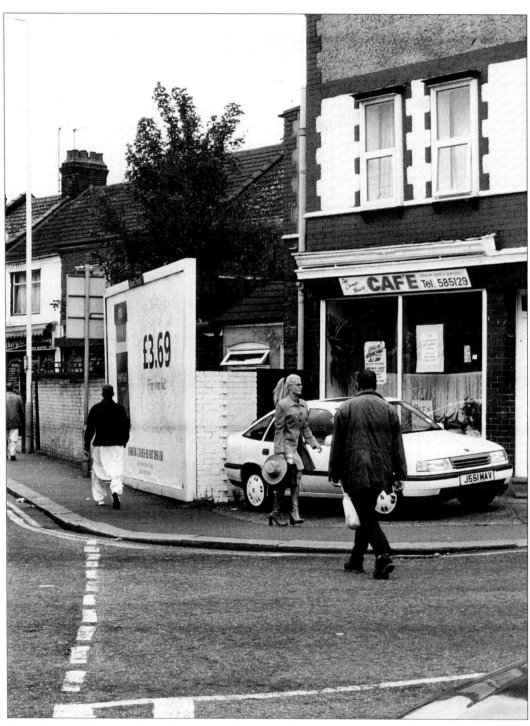

Luton today, at the junction of Althorp and Leagrave Road. Althorp and neighbouring Spencer Road conjure up memories of a past and powerful aristocracy, but this is a 'modern society', as the Prime Minister would say! A strikingly dressed young lady carries a distinctive hat, reminding us how important headwear has been to the town's history. (*Robert Cook*)

LUTON
PAST & PRESENT

ROBERT COOK

The
History
Press

First published in 2002 by Sutton Publishing Limited

This paperback edition first published in 2013 by
The History Press
The Mill, Brimscombe Port,
Stroud, Gloucestershire, GL5 2QG
www.thehistorypress.co.uk

British Library Cataloguing in Publication Data
A catalogue record for this book is available from the British Library.

ISBN 978 0 7524 8864 6

Illustrations

Front endpaper: Vauxhall Motors Ladies Choir, *c.* 1958. (*Vauxhall Motors*)
Back endpaper: Luton from the air, 15 July 1947. (*Simmons Aerofilms*)
Half title page: Junction 10 of the M1. With an array of stylish new models the Vauxhall car company gets ready and 'with it' for the Swinging Sixties. The M1 would soon open, bringing new life to Luton and a fast track out – though not so fast today! (*Vauxhall Motors*)
Title page: Wellington Street, and a local passes a shop offering an alternative to waiting for the sunshine. (*Robert Cook*)

Typeset in 11/14pt Photina and produced by
Sutton Publishing Limited.
Printed and bound in Great Britain by
Marston Book Services Limited, Didcot

Contents

Park Road, Luton, *c.* 1900, when the population was a mere 36,404 and there were many leafy lanes. (*Author's Collection*)

Introduction

Luton's origins lie in accidents of geology and geography. It developed on a fan-shaped wedge of gravel at the northern end of the Lea gap. Only 30 miles from the centre of London by road today, it was bound to prosper. There were hunter-gatherers here 250,000 years ago, living by hillside lakes. When the ice-age glaciers melted they flowed through the gap, eroding the chalk hills and leaving habitable spurs like Galley Hill. The Icknield Way eventually provided an important link to East Anglia and Wiltshire, and became a major trade route.

It was the Romans who first came and cracked the whip. Arriving in 55 BC, they built Watling Street through the Downs. After they left, this area became part of King Offa's Mercia and he gave 500 acres to the Abbot of St Albans in 792. Vikings later passed this way and the settlement was prosperous by the time it was assessed for William the Conqueror's Domesday Book in 1086.

Henry II (1154–89) handed the manor of Loitone to his illegitimate son Robert, Earl of Gloucester who built a new church south of the existing St Mary's. Then the manor passed to Earl Baldwin de Bethune for £80 and in 1214 when his daughter Margaret de Redvers married William Baldwin, Luton was the dowry. After she died in 1216 King John insisted that his friend Falkes de Breauté should have the land. This man's vast, often dubiously acquired, wealth already included Falkes Hall, corrupted by degrees to Vauxhall – the locality where the famous car maker originated centuries later.

Our modern society was established in an often brutal fashion, something easily overlooked in a civilisation preoccupied with rights yet bedevilled by rising crime. Study the history of aristocrats like Falkes de Breauté and monarchs like King John and they appear little better than the modern mafia. But their iron fist helped create order, albeit one that suited their kind rather than the ordinary Luton people. In the centuries that followed, the town continued to grow and develop.

When non-conformity became a significant force in the eighteenth century, John Wesley (ordained in 1728) returned from missionary work in Georgia to become an open-air preacher. He met with hostility whenever he visited Luton. The local clergy's attitude, which extended to refusing to ring the bells or help him into his gown, was part of a process that drove him to found his chapel-based religion. Luton's first Wesleyan chapel was built opposite St Mary's in 1778 and used for forty years before the congregation moved to Chapel Lane.

Differences of religion generated conflict and rivalry in the town. For example, Baptists, who built a fine chapel in Waller Street, took the view that only those who have faith in Christ should be baptised, which ruled out infants. The Methodists

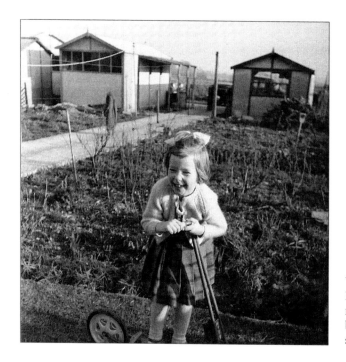

Young Jane Pilbeam in her Chesford Road garden, late 1950s. There's a nice Rover 90 parked by the garage, but this little one looks happy with her scooter. (*E. Griffiths*)

took the opposite view and the two factions divided. And then internal dissent split the Baptists; the Ceylon Baptists founded their own chapel in Union Street. Multiculturalism is no new thing; it is just the jargon has changed.

Jargon and language play a big part in the development of society. If we really went back in time, instead of just looking at old photos and a few words, the language of bygone days would seem strange. People were so much more restrained in so many ways, and it is well to remember that when lamenting the loss of the 'good old days'. Audrey Wash recalled:

My father was top dog in the home. If you tried arguing you got a good hiding. I enjoyed school, except in the top class where the teacher was ruler-happy. I wanted to go to the High School and put in for the exam in 1938. A letter came home saying I had passed. My father did his nut; 'You think I'm going to pay for a great lazy girl to go to High School!' The teacher said, 'Never mind. When you leave school you can go to the technical college.' But by the time I was ready for that the town was full of soldiers. Mother wouldn't have me walking through Park Square to the tech.

I went to work at Mailers in Moor Street, opposite the Odeon. I enjoyed working there. They made beautiful leather luxury goods for Harrods. We made RAF helmets for the war effort. I was always good with my hands. I started on 12s 6d a week, and by the time I was fifteen years old I was getting 16s, and then piecework took me up to £4 a week.

There were important factories in Luton. German bombers used to follow the railway line. . . . There were some bad raids. Being a teenager I thought it was exciting. There were lots of dances. We had a whale of a time. Glenn Miller played at the American base

and they sent lorries out to bring girls in, but mother would never let me go. I don't know why! But we girls weren't afraid to walk down town. We called it the Monkey Parade between Wardown Park and Mill Street. You put your best clothes on and walked up and down; the soldiers ogled while we giggled. We didn't speak to Americans. You were a bad sort of girl if you went out with them.

An end to all hardship and shortage was hoped for in 1945. The statue outside the Town Hall bears the optimistic symbol of an olive branch, and the memorial reminds us of so much sacrifice.

A CHANGING TOWN

The years of Luton's greatest change came in the nineteenth and twentieth centuries. In 1900 George Street was a narrow lane. Favoured by hat makers, bleachers, dyers and sewing-machine makers, it was to alter dramatically in the years that followed. The first railway station, at Bute Street, connecting Luton to London via Dunstable, was opened in 1858. It proved valuable in reviving the hat industry which had been in decline since oriental imports flooded in after the Napoleonic Wars. Building trades flourished as the town grew, though the Earl of Bute created a fine bulwark against southerly expansion with Luton Hoo and its fine gardens.

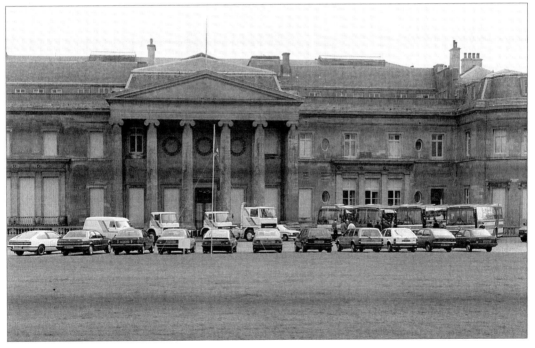

A fine display of Vauxhall- and Bedford-built cars and commercial vehicles in front of the equally well-designed but more substantial Luton Hoo, early 1980s. (*Vauxhall Motors*)

By 1914 Luton was pressing for borough status, but its population of 49,978 was 1,022 short of the figure needed to qualify. Not until 1945 was it agreed to merge the police and fire brigade under delegated powers, and full borough status was not granted until 1963.

Houses condemned over 100 years before started tumbling in the 1950s while new, planned housing estates like Farley Hill took shape. There were 1,200 empty houses before the war, but pressure of demand doubled prices in 1945.

The new borough accelerated its plans during the 1960s. Sadly, good buildings went as well, like the Carnegie Library and Grand Theatre. The town's first post office in Cheapside crumbled into dust in April 1973 as phase two of the Arndale Shopping Centre began. Brand new building plans were rolled out by confident engineers and a new town centre took shape.

Migrant workers make towns grow. They came first from the Bedfordshire and Buckinghamshire countryside, taking advantage of opportunities for work and better

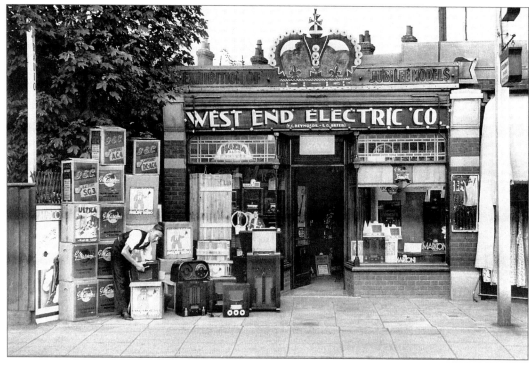

West End Electrical Co., 180 Dunstable Road, with televisions and radios ready for the coronation of Queen Elizabeth II in 1953. This was a busy shopping area and electricity offered new possibilities with so many new domestic appliances. Audrey Wash recalled watching television for the first time with her mother-in-law: 'It was a tiny square picture. We saw the coronation, all crowded around. Reception was poor in Ivy Road because of wire netting around the football ground. The picture rolled every time planes went over. So they put in cables in 1957/8. People won't believe how early we had cable TV!' (*Luton Museum Services*)

14

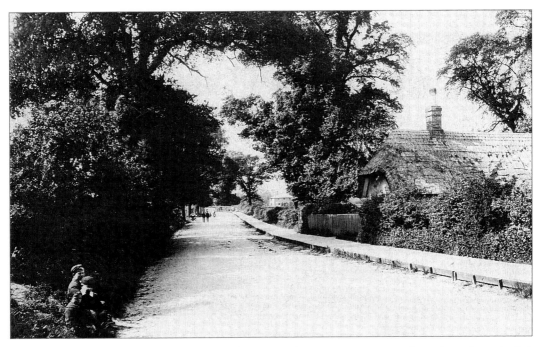

An idyllic scene in Park Road at the turn of the twentieth century, a century of massive upheaval – but these youngsters are just enjoying the day. (*Author's Collection*)

pay. Many were employed by the Vauxhall Ironworks, which was founded to make marine steam engines, but by 1902 was involved in creating petrol-engined cars. The company moved to Luton in 1905 to find more space and to concentrate on car making. Success encouraged General Motors to mount a takeover in 1925. It needed a base to manufacture its Chevrolet trucks, which were redesigned for the British market in 1931 and marketed as the Bedford. The vehicle's success carried the company for many years and provided high employment through the difficult 1930s. Hard-hit Clydeside thus found an outlet for redundant workers who flocked to Luton, a trend that continued for many years. Bedford also became the premier supplier of army lorries.

During the 1960s many Irish building workers came to town, along with others hell-bent on enjoying the feast of opportunities available. Such was the prosperity of Luton in the 'Swinging Sixties' that the town was chosen for a sociological study by Messrs Goldthorpe and Lockwood. It aimed to test whether the well-paid Luton factory worker was so liberated by income that he could adopt a middle-class lifestyle. During 1963–4 they studied 229 factory workers and a comparative group of fifty-four white collar workers from Vauxhall, Laporte and Skefko Ball Bearings. Sadly, they concluded that the new working class did not have the knowledge to enjoy the pleasures of the middle classes, and lacked the support structures of the old working-class communities now left behind.

Much has been done by the state to make up for the demise of old communities, but in a large and complex town like modern Luton it cannot be assumed that everyone gets what he or she needs. That is why a forward-thinking borough council is dedicated to building a better Luton. Of course there is crime – everywhere has it and it is nothing new; there have been well-publicised problems on Marsh Farm Estate, and more money and opportunities are needed in poorer areas. Progress takes time, but the Luton First initiative aims to hasten improvement. Already, new businesses are lining up to move here and nightclubs like Liquid Euphoria are getting national recognition. Many of the older generation will miss the Co-op department store in Manchester Street, but life moves forward and the town's growing population now has a fine multiplex and entertainment centre on the site. To help keep things moving, there are plans to create Translink on the disused Dunstable railway line; the £100 million scheme should open in 2005 and will use low-emission fuel.

Luton was proud to make its bid for city status in the Queen's golden jubilee year and it is to be hoped that it will have better luck next time. Meanwhile, the town has much more to look forward to. It is a model of successful multicultural society.

Robert Cook
July 2002

Looking Down on Luton

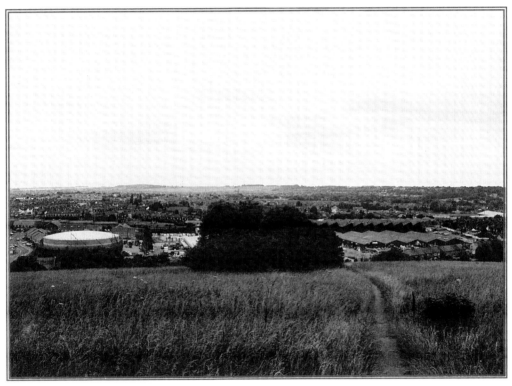

Looking down on Dallow Road from Winsdon Hill, a view well revealing the natural beauty of the locality. It's become fashionable to look down on Luton regardless of how damaging jokes can be, but the town is having the last laugh. Employment levels are very good, new industry is keen to move into a skill-rich area and the university is teaching what people need to know to live and work in the twenty-first century. The town has always been adaptable and not afraid to face a challenge. In doing so it is one of the most successful multicultural societies in Britain. (*Robert Cook*)

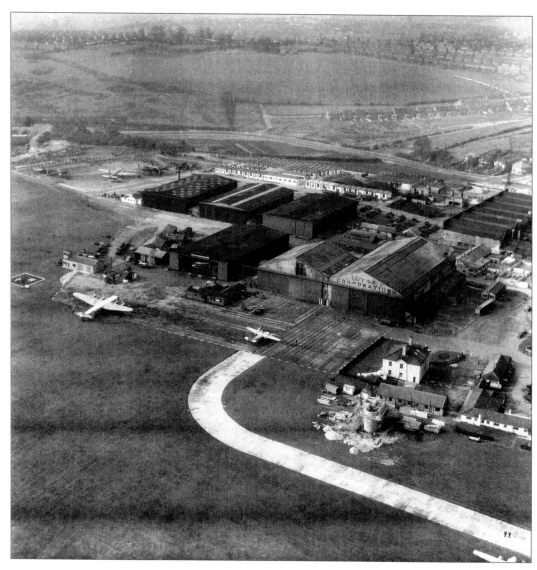

The future Luton International airport on 1 November 1951. Luton Corporation's faith in the future is marked boldly on the main hangar. Wartime's contribution to the advance of passenger airways is evident in the converted military aircraft in the foreground. The site attracted cutting-edge technology in the shape of English Electric, Percival Aircraft and Napier's. (*Simmons Aerofilms*)

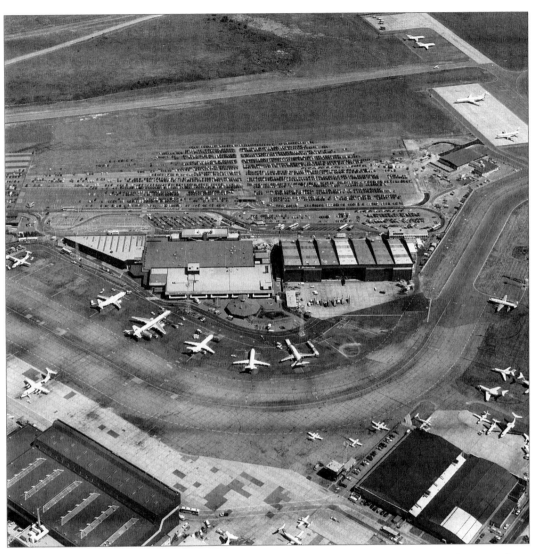

London Luton Airport, just east of the Vauxhall car plant, 1990. Aviation technology has moved on remarkably, with Luton playing its part. The airport opened on the site of Eaton Green Farm in 1938 and a concrete runway was built in 1960. Percival Aircraft was based here during the Second World War and 245 plywood De Havilland Mosquitos were built here. Autair was among early postwar users and its operations manager, Bill Buxton, was alerted to inbound flights by a brick on a string that rapped the roof of his caravan, which was parked below the control tower. It was a buccaneering industry, which thought nothing of using Dr Kingsmill, a weekend freelancer, to fly one of its ex-RAF Dakotas. (*Simmons Aerofilms*)

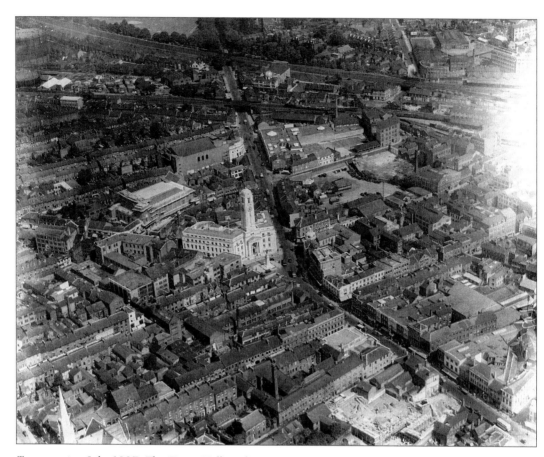

Town centre, July 1937. The Town Hall is almost exact centre, with George Street cutting valley-like toward it, running on into Manchester Street. Behind the Town Hall, the Ritz cinema and Alma theatre, which finished its days as the Cresta ballroom before making way for offices, are prominent landmarks. Boots and the dome of the library, built with money from Andrew Carnegie, the American steel magnate, are clearly visible at the junction of George Street and Manchester Street, the latter having a complete run of buildings on its north-eastern side. Most significant of the times are all the old factory buildings associated with hat making. King Street Congregational church, bottom left, was demolished in 1970 because the steeple was judged unsafe. The roof of the Savoy, later ABC, cinema can be seen at the end of the block, about halfway along George Street. Across the street are the densely packed buildings, including the covered market, which would eventually make way for the council-backed Arndale Development Company's project. John Cheevers, who came to Luton from Ireland in the 1960s, remarked that the Arndale was a good place for pensioners to sit, have a smoke and chat, before new health rules banned smoking. Stuart Street is visible running past the tower. (*Simmons Aerofilms*)

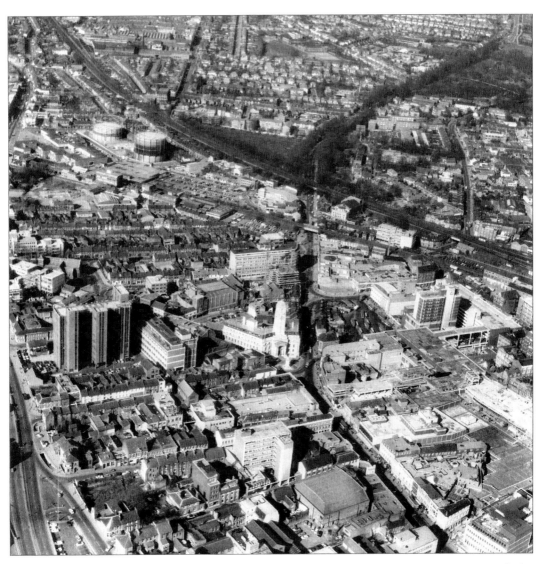

This picture shows a similar, though wider angle, view of the town centre in summer 1976, with the GPO's towering office blocks growing as if some mad giant has been out planting evil seeds. The massive Arndale Centre development is well under way. The King Street chapel has gone and there is a glimpse of the new dual carriageway which follows the line of Stuart Street. The ABC cinema can be seen just off centre in the foreground. (*Simmons Aerofilms*)

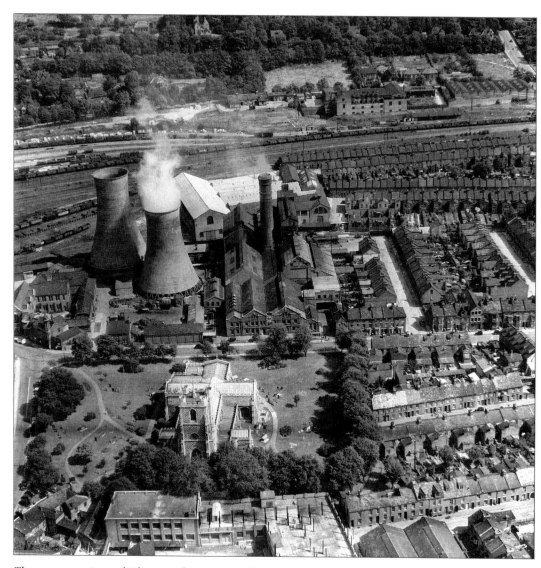

The power station, which was taken over by the state as part of postwar socialism's plan to control infrastructure and subsidise where needed. Seen here on 21 August 1951, it was ideally situated close to the railway line coal sidings. There were no apparent worries about acid rain, though many had faith in the new nuclear power. St Mary's church, a beautiful building, looks an incongruous neighbour. This plant worked wonders to meet excessive wartime demand, reaching 61,500kw by 1945. New building work is seen under way at Luton Technical College, now part of the university, in the foreground. The fire station can be glimpsed in Church Street, just left of the cooling towers. Built in 1901, it closed during the early 1960s. (*Simmons Aerofilms*)

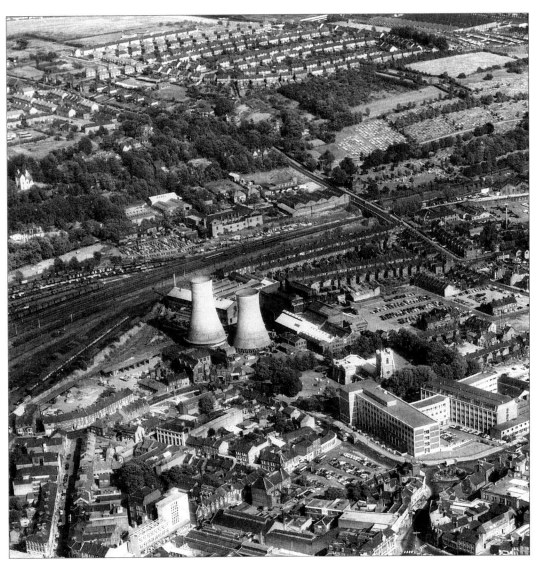

Little had changed by the time this photograph was taken in September 1964. High Town was notorious for slums and lack of surface drainage in its early days, but after the war there was much new building off Devon Road. The Technical College also looks very bright and modern. Luton was now a borough and things were starting to happen here. (*Simmons Aerofilms*)

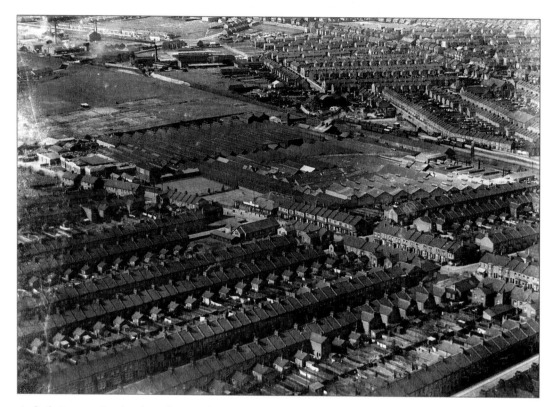

A dark image of a hard-working industrial town, Dallow Road, 12 April 1932. Davis's gas stove factory is almost in the centre of the picture. Laporte's premises were toward the left of the picture. These rows of workers' houses and tiny gardens contained so many lives and stories long ago. Audrey Wash recalls her husband serving his tool-making apprenticeship, working at Davis's and then Jackson's, which made shells during the Second World War. When the firm moved to Bristol Mr Wash went to work at Vauxhall. Mrs Wash said her husband enjoyed his work. She said: 'A long time ago I went on a tour of Vauxhall; there were men everywhere. When I visited years later it seemed to be all robots.' (*Simmons Aerofilms*)

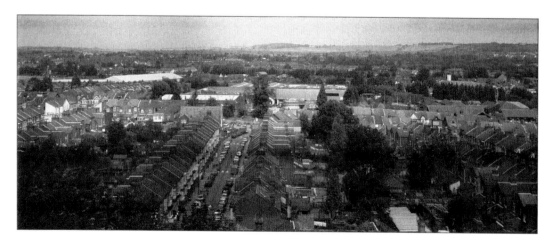

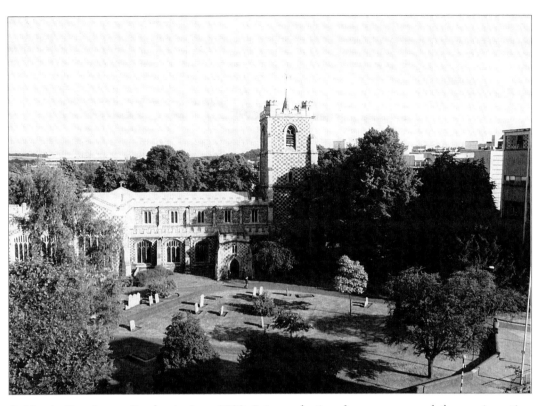

St Mary's Church, one Sunday in June 2002. It is nearly time for evensong, and the sun is casting shadows across the trees and late arrivals. University buildings are visible far right and the Technical College is no more. (*Robert Cook*)

Opposite: A view over Dallow Road, August 2002 and the grim industrial image has faded. Homes are brighter and modern factory units more cheerful and lighter in design. Workers nowadays have better conditions and the government, since the Second World War, has been obliged to maintain high levels of employment. In the material sense, people are on average better off. This view looks directly towards the old Davis gas stove factory. Betty Davis, née Russell, studied shorthand and typing at high school where she was junior running champion in the 100-yard race. She remembers the headmistress, Miss Sheldon, who had a booming voice. Betty went on to work at Davis's during the war. She was never late and remembers the 'nice friendly atmosphere'. (*Robert Cook*)

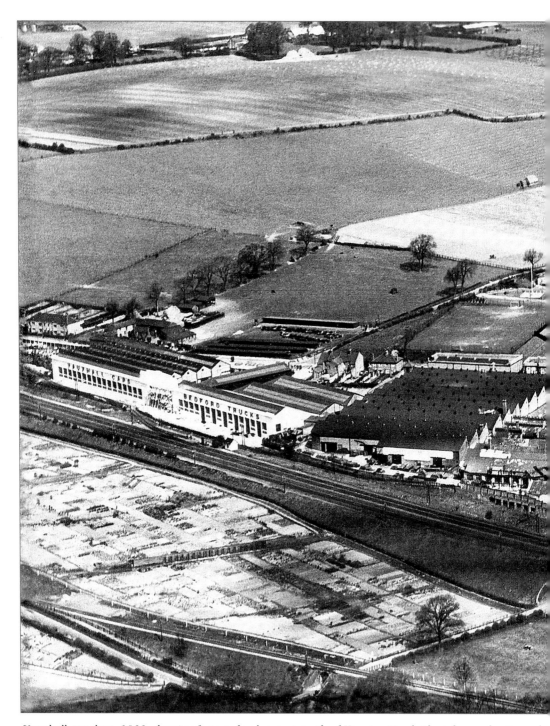

Vauxhall car plant, 1933, showing factory development south of Kimpton Road. The takeover by General Motors is evident from the name Bedford Trucks alongside Vauxhall cars emblazoned over the side of the factory which fronts the railway line. The original managing director's house and the new HQ in Kimpton Road are visible just below the sports fields. Kimpton Road leads away, far right, running north-

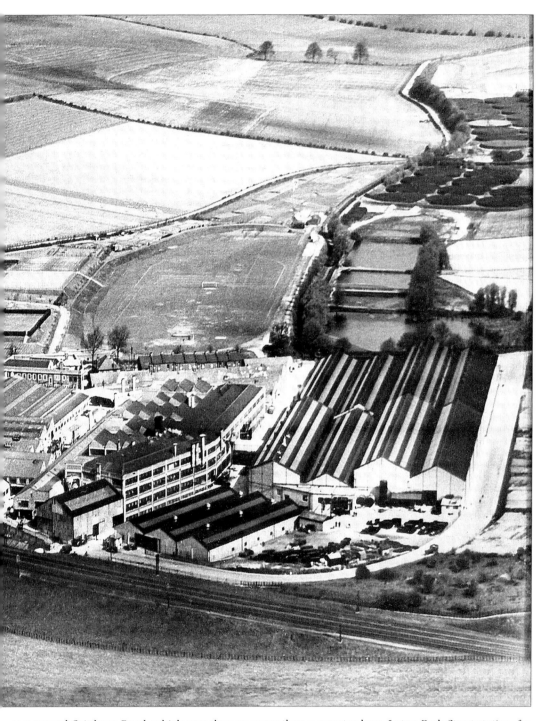

east toward Spittlesea Road, which was then no more than a country lane. Luton Park Street station, for airport passengers, and a large B&Q store have been built on the redundant land to the bottom left of this picture. (*Vauxhall Motors*)

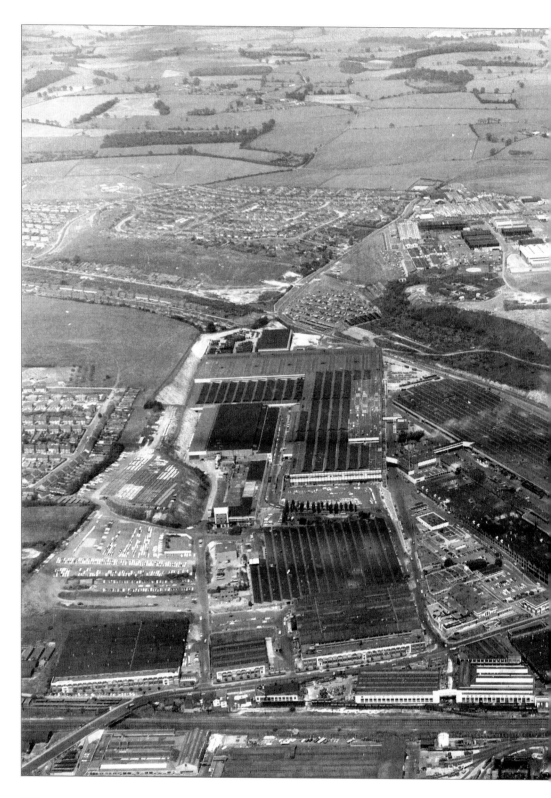

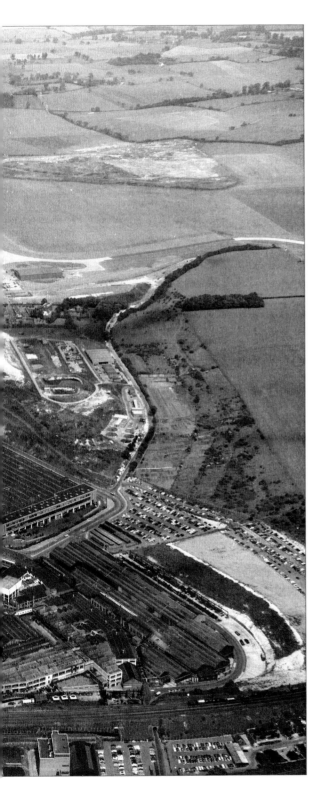

Vauxhall Motors, early 1960s, and massive development north of Kimpton Road is evident. During 1955–7 the company spent £36 million to double car production, excavating over 1.5 million tons of chalk and clay from the Chilterns, creating 1.6 million square feet of building. The spoil was used to extend Luton Airport by 12 acres. The new AA block is the rectangular roof below the airport. It was one of the largest steel-frame structures of the day – steel came from the United States because of British shortages. The material was originally designated for a wartime GM plant making bombers in the US. In this view Spittlesea Road is still very much a lane and Crawley Green Road the main route to the airport. The age of Lorraine Chase and the package holiday had yet to arrive, but it was not far away. (*Vauxhall Motors*)

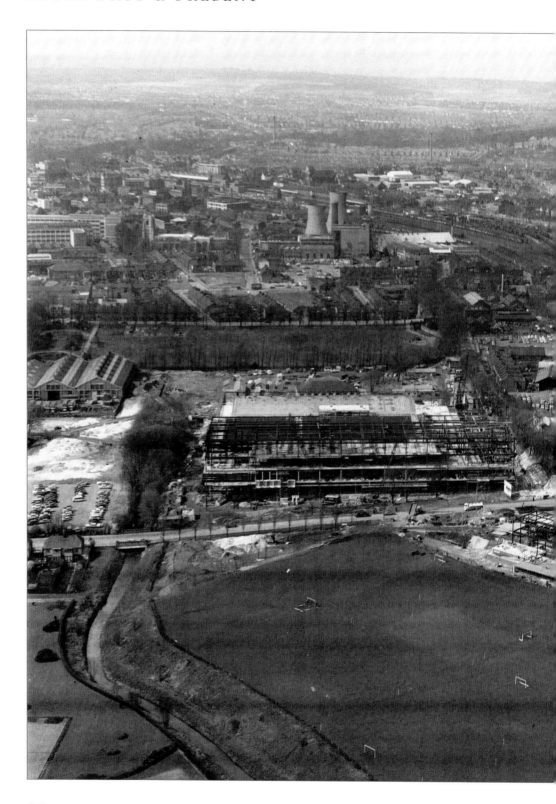

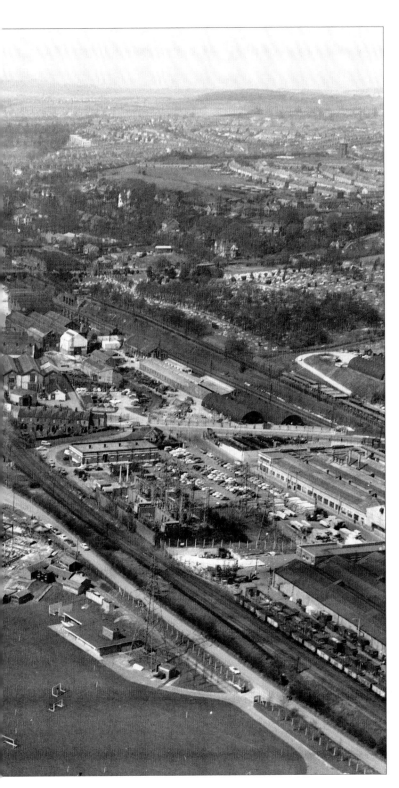

Looking north-west across
Vauxhall developments
in the late 1950s, giving
a fine outlook over the
Chilterns and landmarks
of the power station,
Technical College and
St Marys. High Town is
clearly visible, top right.
(*Vauxhall Motors*)

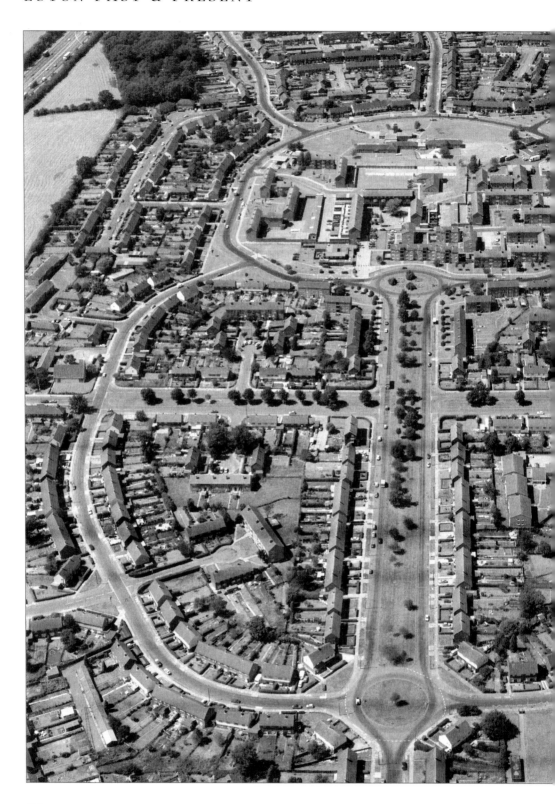

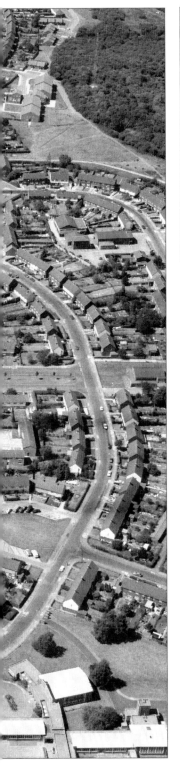

Farley Hill Estate, June 2002. The development began soon after the war ended on redundant farmland when it was cheap. John Creasey remembers when Longcroft Close was built; he used to play on the building site. He recalls the local view at the time, that the estate was a bit rough, being early overspill for Houghton Regis. While taking this picture I had to jump out of the way of two competing hot hatchbacks, but I suppose boys will be boys! The roads around Farley Hill have got more exciting curves than Silverstone and more overtaking opportunities! (*Robert Cook*)

Farley Hill Estate, looking along Whipperley Way to Whipperley Ring. The close proximity of the M1 can be seen top left. The estate was built, with some flair for design, to cope with housing shortages, population growth and overspill. The road layout, developed with safety in mind, is easily abused by boy racers. (*Simmons Aerofilms*)

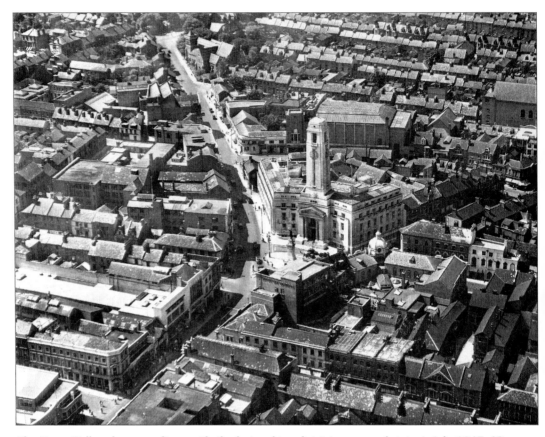

The Town Hall and surroundings with the hat-making district very much intact, July 1947. (*Simmons Aerofilms*)

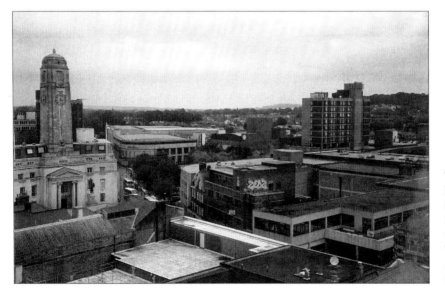

The Town Hall, Manchester Street and the old hat-making district viewed from the Tax Office, August 2002. (*Robert Cook*)

Solid Ground

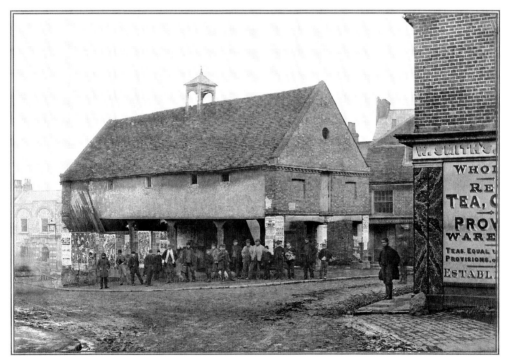

The Market House, Market Hill, *c.* 1867. Luton was a major market centre within the county, serving the farming community and growing town. The population grew from 2,986 in 1821 to 36,404 by 1901. Much early housing was jerry-built and densely packed, with the absence of surface drains causing disease in some parts. Warehouses and factories springing up around the centre were grim and functional, with poor attention to health and safety. Prosperous owners moved to fine houses on the town's fringes. A growing population needed entertainment, and the town gained two fine theatres, the Grand being opened by Lily Langtree herself. Major modernisation had to wait for nearly a hundred years after this picture was taken, though a new Gothic-style Corn Exchange opened on Market Hill in 1869. (*Luton Museum Services*)

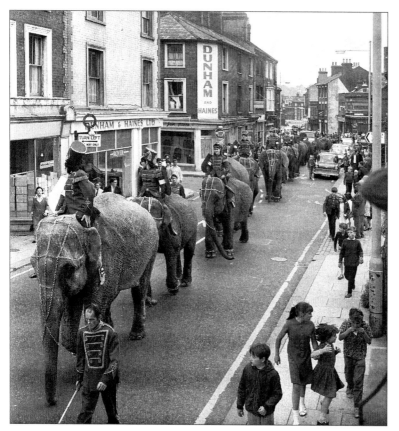

Many locals will recall the Vauxhall workers' children's trips to Bertram Mills Circus at Olympia in London, the excitement of the train journey and being greeted by the stilt walker and clowns on the station. In this case, though, the circus has come to town, and it's Billy Smart's in 1967. The elephants are parading down Castle Street, away from the centre. The Dog public house is just visible, top right, near the junction with Langley Street. (*Luton Museum Services*)

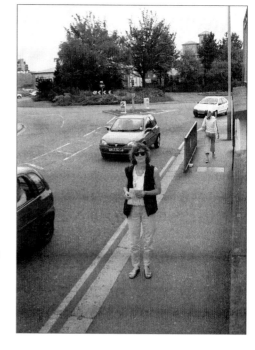

The scene today is much changed. All the old buildings had to make way for a big new roundabout when Stuart Street became part of the ring road. Fortunately the Union chapel survives and this picture was taken from its steps. Langley Road now stops well short of Castle Street. (*Robert Cook*)

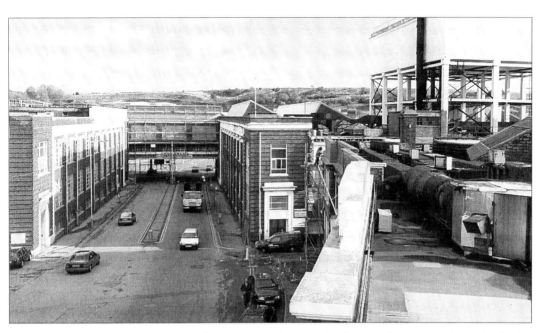

Vauxhall's car factory seems to have been an ever-changing landscape. This picture shows the bridge connecting the plant across Kimpton Road, viewed from S-block roof in the early 1990s with demolition under way. (*Vauxhall Motors*)

The same scene viewed from a similar angle, July 2002. The plant has vanished from south of Kimpton Road. (*Robert Cook*)

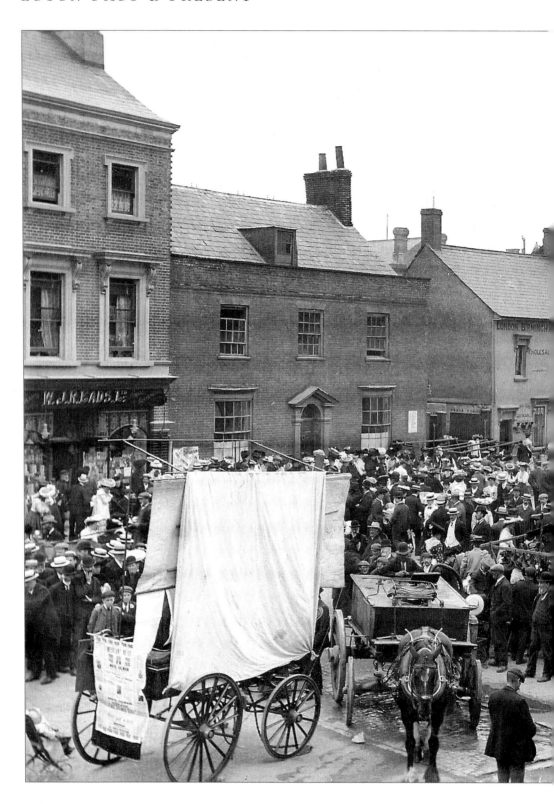

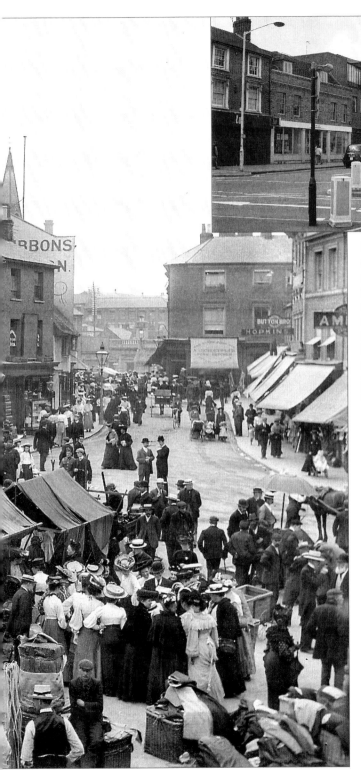

Park Square, July 2002. Very little of the old surroundings survived redevelopment, though traces are visible to the left of the picture, on the north-western side of the square. The large modern building, extending towards the centre, includes a Pizza Hut. Modern needs dictate changes. There is no place for market stalls here today. (*Robert Cook*)

Park Square, market day, 1906. This vivid scene is full of life: one can imagine the noise and array of simple goods on offer. If we could really step inside this picture it would be like arriving on another planet. The same site is barely recognisable today, though some of the buildings on the western side retain an old-style frontage and the former Boots the chemist on Market Hill survives as an estate agent. (*Luton Museum Services*)

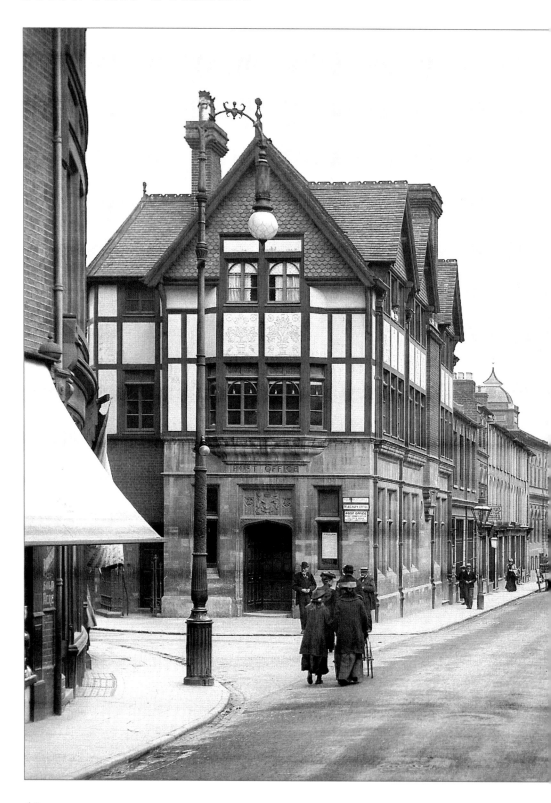

Cheapside, June 2002, on a sunny afternoon, contrasting the style of the old in the foreground and the new, which has covered much of Cheapside up ahead. Arndale made such a difference, but would Luton want to be without it? (*Robert Cook*)

Cheapside, showing the stately looking post office, *c.* 1908. Cheapside was at the centre of the hat-making industry and there are still remains of old factories in the area, along with boarded-up and neglected properties covered in fly posters and awaiting redevelopment. (*Luton Museum Services*)

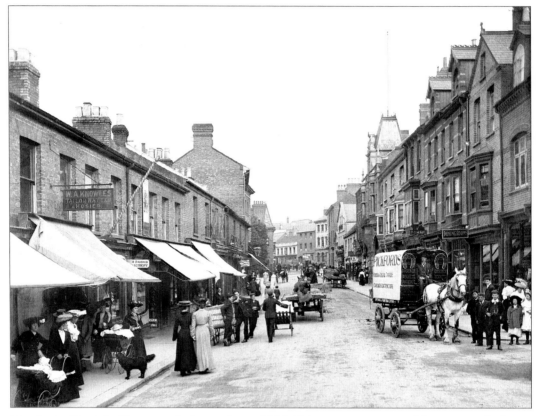

Manchester Street, looking towards George Street, 1906. This was a street so confident in its style that it included a cinema called the Ritz. Style is evident in this busy scene. (*Luton Museum Services*)

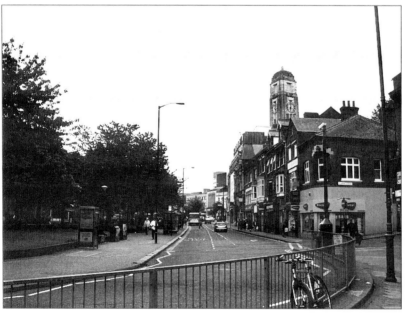

Manchester Street, July 2002. Half has been cleared to make room for a temporary bus terminus, open space and Arndale. Close inspection reveals some of the old building line intact, with the weathered tower of the 1936 town hall rising above it all. (*Robert Cook*)

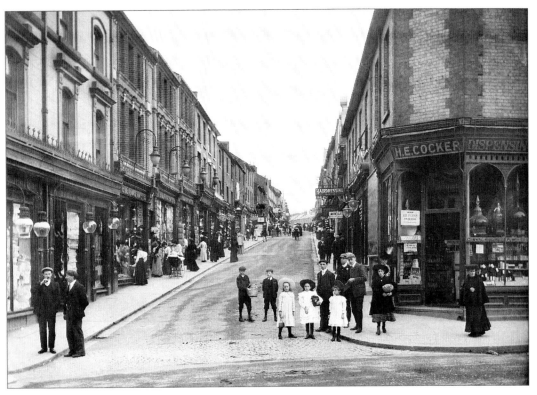

Wellington Street, which runs south-west to Stuart Street, viewed from George Street in 1906. Cameras took their time in those days, so the poses look a little odd. (*Luton Museum Services*)

Wellington Street was a premier shopping venue, but times have changed. However, superficially it looks much the same in June 2002. Building societies were not a vital element of life back in 1906; neither were US-influenced shop names like Showboat. People like things to sound glamorous, and things American have never ceased to impress the British – mainly because of wartime troops and the legacy of American popular music. The penny-farthing cycle stands make a fine detail and finishing touch in the foreground. (*Robert Cook*)

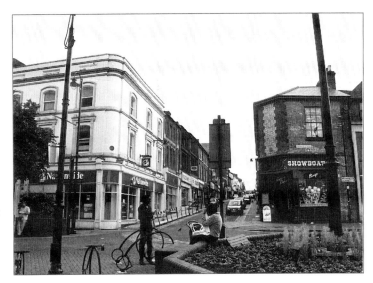

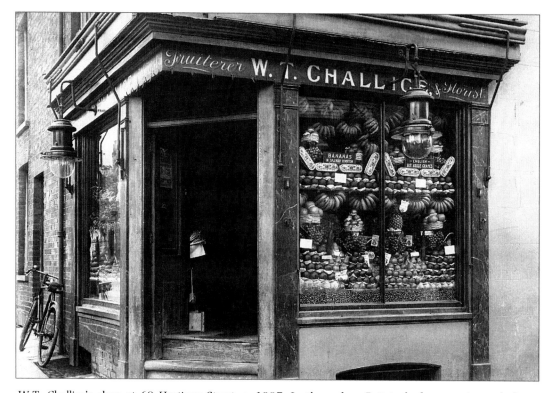

W.T. Challice's shop at 60 Hastings Street, *c.* 1907. In those days Britain had an empire and cheap food was available from all over the world. This display of foreign fruit looks particularly exotic. (*Luton Museum Services*)

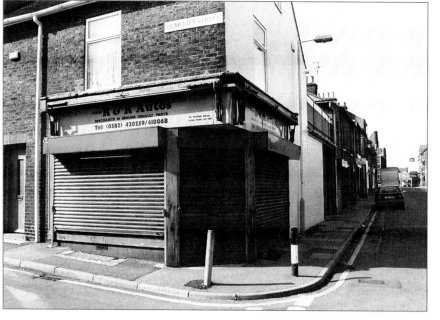

The same premises today show some changes, though the frontage is still recognisable. There is still a link with foreign wares, but now this has to do with the ubiquitous motor car – Renault motor spares. (*Robert Cook*)

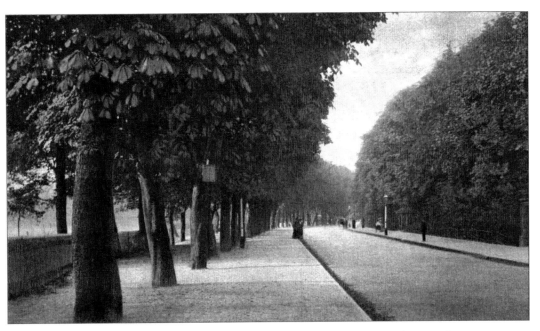

A delightful leafy scene, *c.* 1904, in what was then simply Bedford Road. Wardown Park opens away to the left. (*Author's Collection*)

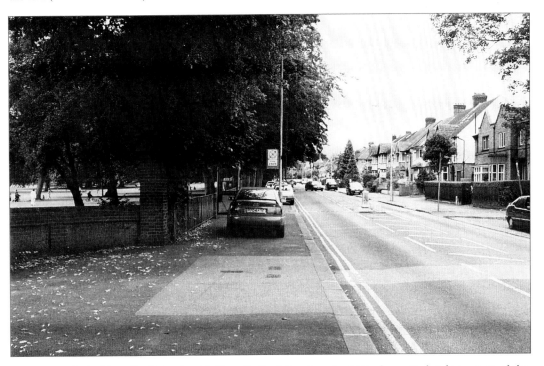

It is now called Old Bedford Road, with New Bedford Road west of Wardown Park taking most of the traffic flow. The road still looks busier than in the previous scene, with parked cars taking over much of the pavement and 1930s development replacing the pleasant foliage of the previous image. (*Robert Cook*)

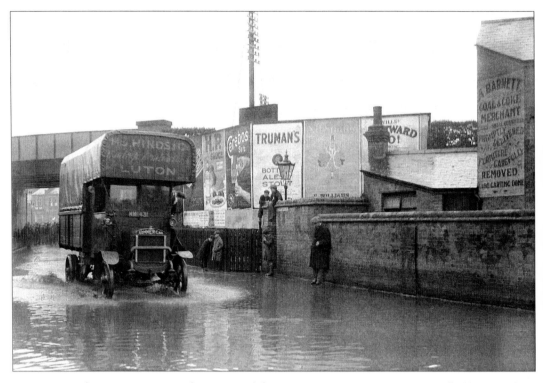

Leagrave Road, May 1924. An early version of the Luton van (Luton vans are so called because hats were light enough to be carried in extra space over the cab) cuts through floods, driving north-west under the railway bridge. Advertising hoardings include the praises of Truman's rather than J.W. Green's local brew. The River Lea runs close by here, and too little provision was made for draining the growing town. Floods were not surprising. (*Luton Museum Services*)

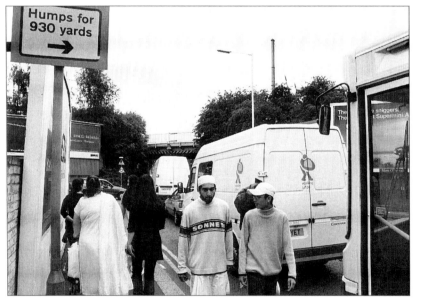

Physically, the same spot is little changed today. Nowadays this is a strongly Asian neighbourhood. Locals are seen returning from the mosque on a Friday afternoon in July 2002, and traffic towards Dunstable Road is heavy. It is still a favoured spot for advertising: here we glimpse a poster encouraging us to buy a particular car. (*Robert Cook*)

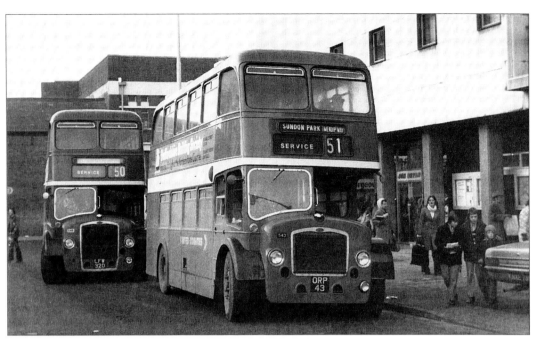

The United Counties Omnibus Company (UCOC) originated as part of a pre-war strategy to bring order to the nation's bus operations. UCOC's operations eventually ran into Cambridgeshire, Bedfordshire, Northamptonshire, Buckinghamshire and Oxfordshire. Its vehicles were mainly supplied by the nationalised companies Bristol and Eastern Counties Coachbuilders. This photo shows two Eastern Counties-bodied Bristol Lodekkas in Bridge Street, *c.* 1971. Part of the old Co-op building is in the background. These 1950s vehicles look in very good order, the rear one coming from the Bedford depot. (*Andrew Shouler*)

The same spot today. The building on the far right remains and is a blood donor centre. Thatcherite Tories long ago scrapped the nationalised bus company, and perhaps few care in this age of the car. The borough council, however, recognises the need for a 'joined up transport policy'. Here we see the little Lutonian bus catering for more limited modern demand. Arriva has replaced Luton & District as principal successor to United Counties. The old Castle Street depot is currently being demolished, ready for redevelopment. (*Robert Cook*)

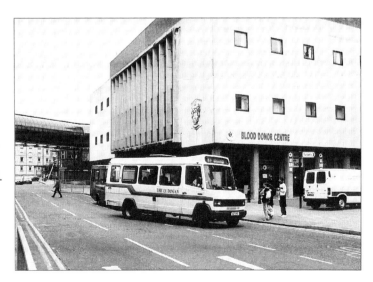

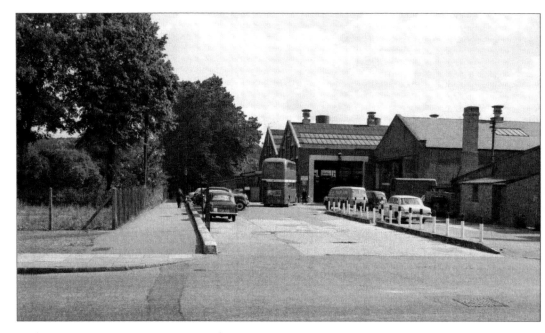

Park Street bus garage, *c.* 1963. A London Transport country service is entering the garage. Originally the tram depot, the site was hit by a 1000kg bomb on 30 August 1940, killing one person. The Germans were aiming for neighbouring Vauxhall, which was engaged in vital war work, including producing army lorries and the Churchill tank. (*Vauxhall Motors*)

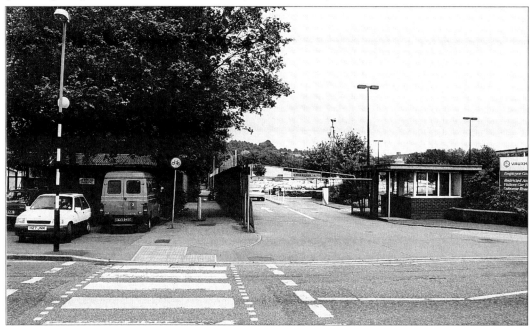

The Park Street premises were taken over by Vauxhall in the early 1960s for sheet metal, wood working and a small research laboratory. Now that facility has given way to car parking. It was demolished in 1989. Vauxhall opened a purpose-built design and style centre in Osborne Road in 1963. (*Robert Cook*)

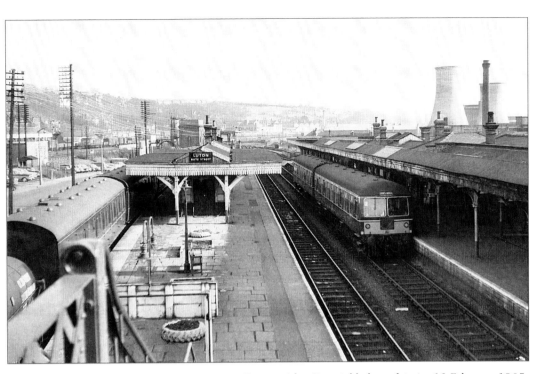

Looking south-west, DMU 2298 at Luton Bute Street, with a Dunstable-bound train, 13 February 1965. The station opened on 3 May 1858, with the first train running to Dunstable. (*Edwin Wilmshurst*)

Looking from the same location today, we see much change. The station was demolished in 1966. The site is now used as a car park, bus terminus and university accommodation. The nation was moving optimistically into the motor age, and around 23,000 were working in the local car and truck factories. Concerns about the future of motoring have encouraged plans to redevelop the old rail route through the £100 million Translink scheme. (*Robert Cook*)

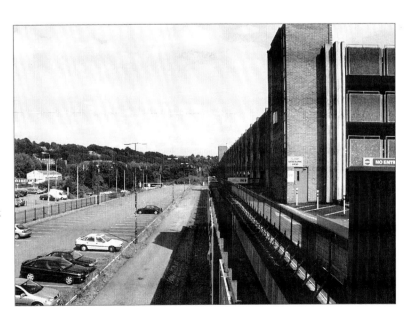

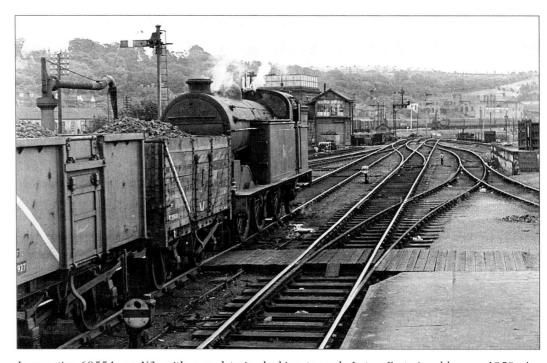

Locomotive 69554, an N2, with a coal train, looking towards Luton East signal-box, *c.* 1959. An 800XX locomotive is approaching with a local service. Luton was linked to the London Midland Scottish mainline in 1867. J.S. Crawley was compensated for land lost, buying that part of Great Moor isolated by the railway. He donated land between High Town and Bedford Road, which would become People's Park, as part of the deal. This is still known as the Midland station. It provided a direct link to London when it opened in 1858. (*A. Scarsbrook/Initial Photographics*)

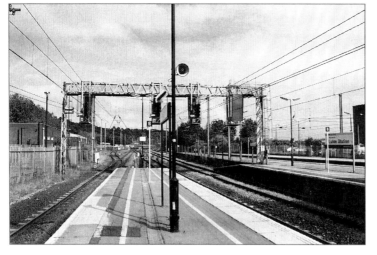

The major changes visible here are the overhead cables and the loss of the Dunstable branch. Electrification of the mainlines coincided with the demise of steam during the late 1950s and early 1960s. This picture was taken on a Sunday in July 2002; it is a quiet moment. Though not obvious, the other major change has been privatisation. This reorganisation is seen by some as disorganisation. The seriousness of the situation has been amplified by recent accidents and a decision to put Railtrack into administration. (*Robert Cook*)

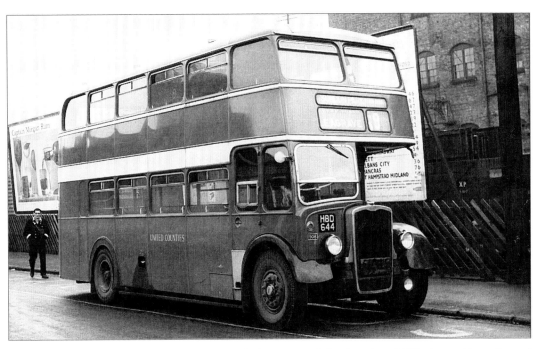

An Eastern Counties-bodied Bristol KSW6B parked opposite Midland station, 1953. A smartly uniformed driver walks towards his vehicle; behind him a hoarding boasts the merits of imbibing Captain Morgan's rum. Another hoarding is glimpsed at the front, advertising cheap pre-decimal fares to nearby stations. (*Andrew Shouler*)

Looking toward the same spot today, advertisements abound. Travellers are being urged to buy cars and travel further afield using the services of Easy Jet via the local airport. A recent survey has shown that British people are the most widely travelled but least adventurous and rudest when they get there! Surely not! (*Robert Cook*)

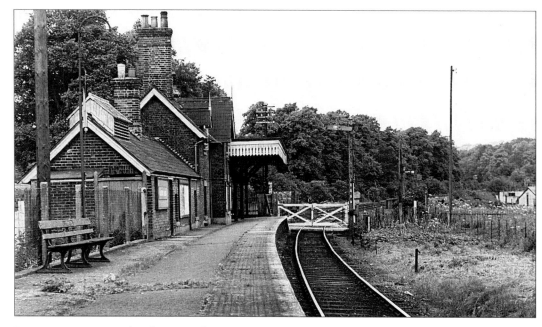

Luton Hoo station, Wheathampstead, on the B653, adjacent to the River Lea and modern sewage works, *c.* 1959. This is a few years before line closure, in the age of Dr Beeching, when the short-sighted view was that railways were old hat. (*A. Scarsbrook/Initial Photographics*)

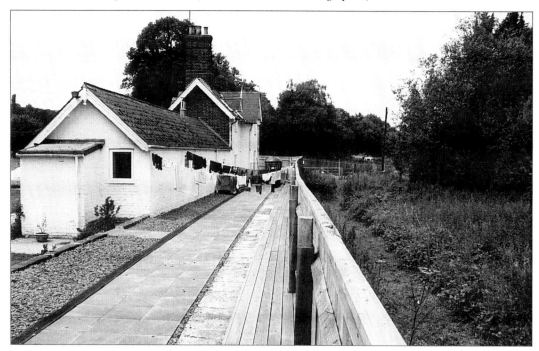

The same location today, photographed with kind permission of the householders who have converted the old station into an admirable country residence. The track has gone, but the new scene easily evokes the charm of the good old days. (*Robert Cook*)

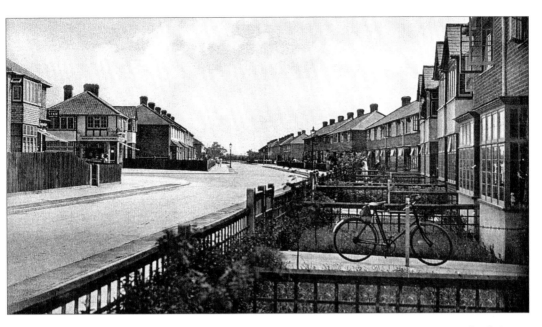

Stapleford Road, Stopsley, off the Hitchen Road, north-east Luton, *c.* 1939. Prime Minister Lloyd George promised homes fit for heroes after the First World War, but politicians' promises have to be taken with a pinch of salt. However, Luton did make some progress during this period. Local builder H.C. Janes constructed this road, complete with little shop. A terraced house could be bought for £450 and bicycles were luxury transport for the average workman. (*E. Griffiths*)

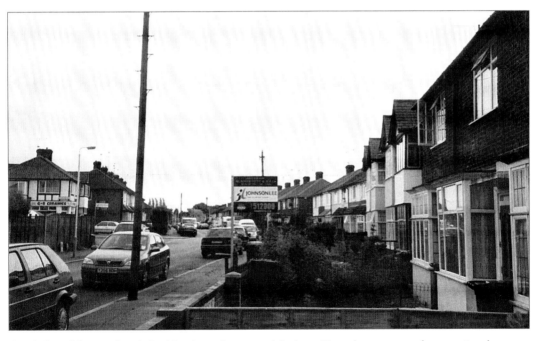

A sale board has replaced the bicycle as foreground feature. Nowadays average house prices here are £70,000 and cars are commonplace – rather a contrast to the previous image. (*Robert Cook*)

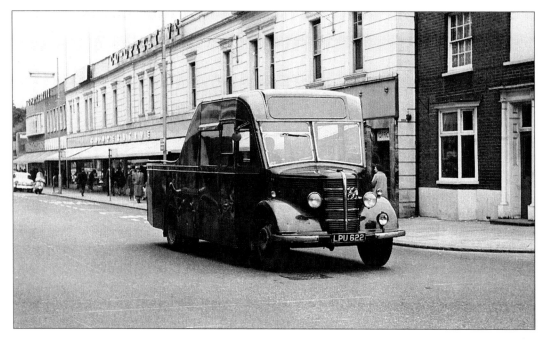

United Counties Bus Company service vehicle, a converted locally built Bedford OB coach, approaches town, passing the old Co-op shop in Bedford Road in 1965. (*R.F. Mack/Andrew Shouler*)

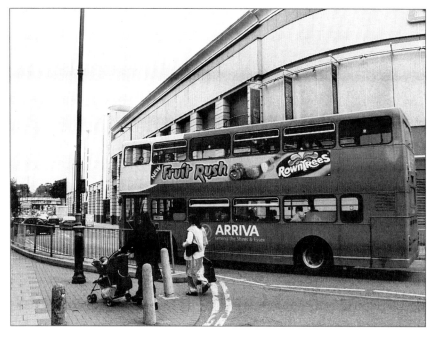

An Arriva double-decker heads out towards the rail bridge. The Co-op has been replaced by the Galaxy entertainment centre, a symbol of today's leisure-orientated society. (*Robert Cook*)

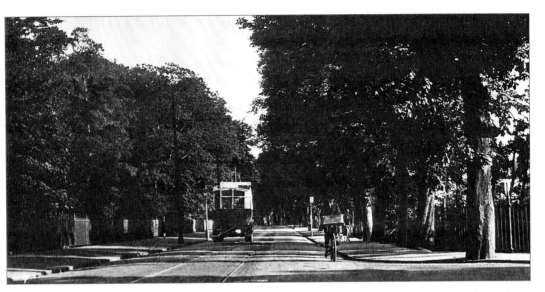

New Bedford Road, *c. 1921*. A motor bus heads north past Wardown Park entrance. The earliest motor buses belonged to Road Motors, starting with services to Hitchin, Dunstable and St Albans. Road sold out to the National Bus Company, which later became United Counties, the main local operator. Controversially, the council wanted to sell its transport rights in 1931, but the government wouldn't let it. Matters had to wait for Mrs Thatcher who forced the idea through. (*Author's Collection*)

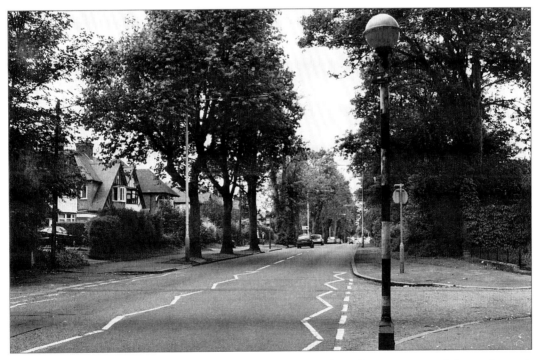

New Bedford Road looks much the same today, though this road can be very congested, hence the need for a Belisha beacon and zebra crossing. Outside swimming pools, or lidos, were popular during the 1930s, and one was built in Bath Road opposite the entrance to Wardown Park. (*Robert Cook*)

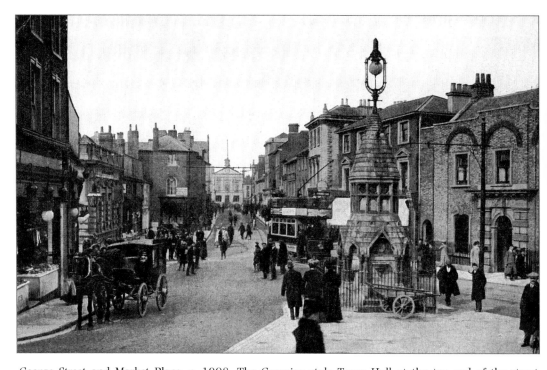

George Street and Market Place, *c.* 1908. The Georgian-style Town Hall at the top end of the street was opened in 1847, symbolic of Luton's growing importance. The population then exceeded 10,000. The clock was installed to mark victory in the Crimea in 1856. The building was destroyed by rioting ex-servicemen in 1919, furious that they were excluded from peace celebrations. The tramway opened in 1908, taking up much of the road. (*Judy Ounsworth Collection*)

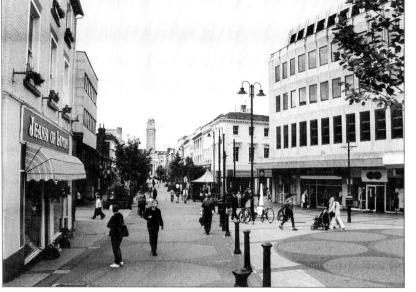

George Street, showing the benefits of 1990s pedestrianisation, July 2002. Trams are long gone; the system closed in 1932, made obsolete by the motor bus. A new Town Hall was built of stone in 1936, its gleaming tower rises in the distance. Few of the old buildings remain after extensive redevelopment which began in the late 1960s. (*Robert Cook*)

Style

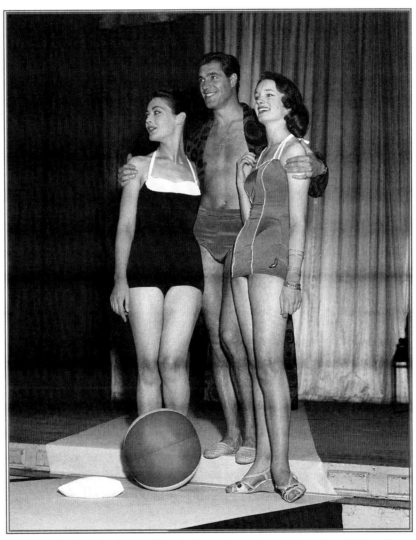

A beach fashion display at Vauxhall works canteen during the 1950s. These three beautiful people are setting a standard for lesser mortals to worry about. It wouldn't be allowed today – on grounds of the stress such displays might cause! Contrary to rumour, Luton has always had a sense of style, including hat designs that led the world. (*Vauxhall Motors*)

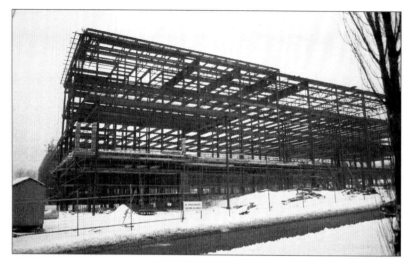

The steel frame is up for the new Vauxhall engineering and styling centre in Osborne Road, 1 January 1963. This was one of the coldest winters on record. (*Vauxhall Motors*)

The completed building, every inch a 1960s edifice, reminiscent of the infamous Centre Point in London's West End. Examples of Vauxhall's nifty modern car design are lined up on the forecourt of the building to be called Griffin House. The Griffin was the coat of arms of Falkes de Breauté whose origins went back to the Vauxhall area of London, just as the car company's did. (*Vauxhall Motors*)

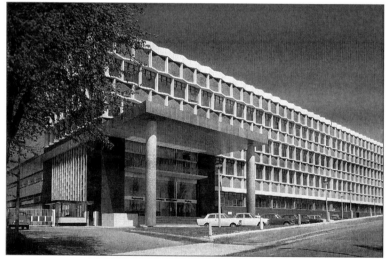

Griffin House, 2002, following a 1990s style facelift. (*Robert Cook*)

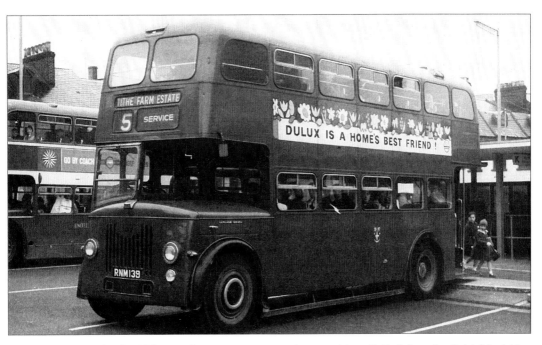

A Corporation Leyland PD2 bus at the town centre terminus next to a United Counties Bristol Lodekka, 1956. Buses might look all the same to some, but to others they were objects of great style and charm once upon a time. This vehicle was taken over by United Counties for training purposes in November 1969. (*Andrew Shouler*)

Today the location has been overwhelmed by the Library Road car park. This scene epitomises what planners thought of as good style during the 1960s and early '70s. (*Robert Cook*)

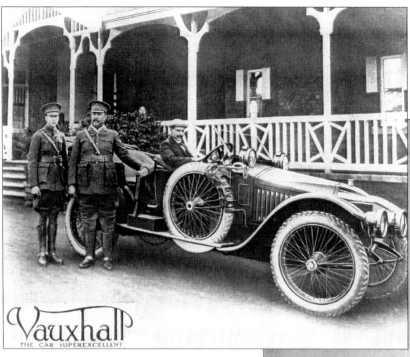

Vauxhall gained a reputation for reliability and style. The company was soon supplying the military with staff cars, like the Prince Henry seen here, for the First World War. In this instance it's not just the car that has style. These military fellows look rather dashing, what! (*Vauxhall Motors*)

This picture takes some beating for style. It was taken in a hired studio in 1957. The 1950s were ending but high fashion was still dictated by the likes of Christian Dior. Elegance was flaunted by models, such as these fine ladies promoting the new top-of-the-range Cresta and being admired by a cigarette-toting gent, looking equally grand. That was style; we shall never see the likes of it again, I fear. (*Vauxhall Motors*)

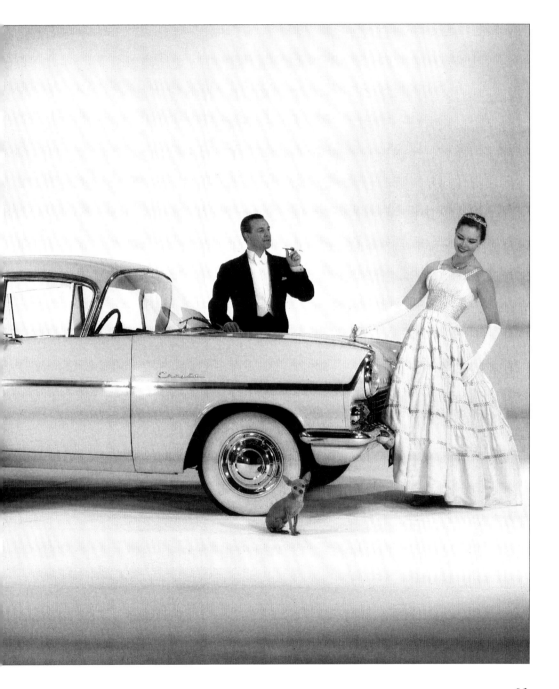

Style on show at a 1930s Vauxhall sports day, *c.* 1935. The rather haughty looking family in the foreground glance sceptically at the camera as a moment in their lives is frozen for us to contemplate. Note the athletes' fashions to the left and the plus-fours wearer, far right. (*Vauxhall Motors*)

People out and about today show a lot less formality and seem in such a hurry. This is lunchtime in Kimpton Road, July 2002. (*Robert Cook*)

Miss Luton, *c.* 1957. In this age of women's lib it has become fashionable to sneer at beauty competitions instead of seeing them as innocent fun, as well as celebrating female charm and beauty. (*Vauxhall Motors*)

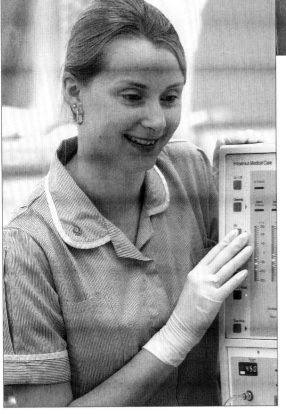

A nurse working at the busy and renowned Luton and Dunstable Hospital. Today's women have little time for beauty competitions, preferring to show their talents in other ways. (*Luton & Dunstable Hospital Trust*)

South African-born actor and comedian Sid James is guest of honour at the 1962 Vauxhall sports day. To many he was the antithesis of more enlightened attitudes to women's role in society. For all that, women flocked to him: he was renowned for his charms! (*Vauxhall Motors*)

Tony Blackburn, less risqué than Sid but still very popular with these ladies at Vauxhall, during a visit in the early 1970s. Tony is the epitome of the softer style in male clothing from that interesting era where older folk taunted that you could not tell the boys from the girls! (*Vauxhall Motors*)

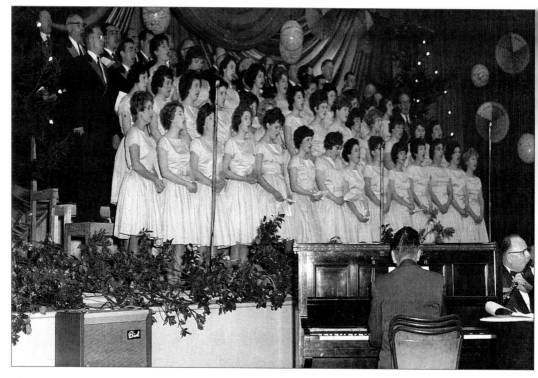

The town is famous for the Luton Girls Choir. This is another fine group from the 1950s: the Vauxhall Ladies Choir, backed by the boys and providing great pleasure at a canteen function. (*Vauxhall Motors*)

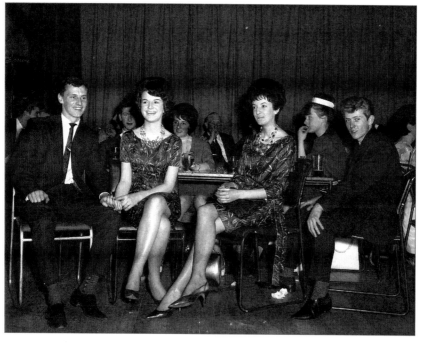

Vauxhall canteen in Kimpton Road was a grand building offering three lunch sittings and a bar, where two lunchtime pints were not unusual. The building also offered scope for regular social gatherings, as here during the early 1960s. It was a place where youthful romance could blossom. (*Vauxhall Motors*)

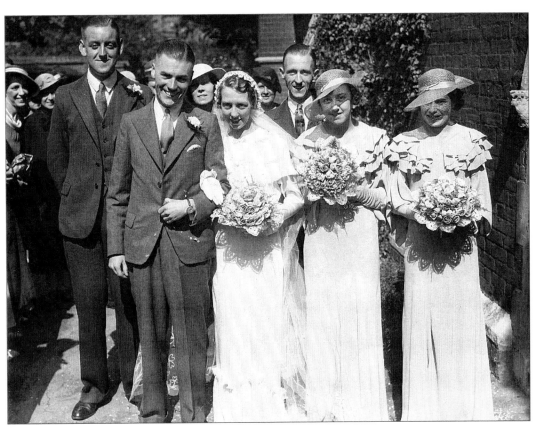

Sid and Elsie Creasey's wedding, 1930s style, at King Street Congregational church. In those days marriage was the norm and usually lasted for life. Everyone here looks happy, though a major war and great upheaval were not far in the future. (*John Creasey*)

Helen Scrivener's wedding to Paul Chadwick in the 1990s, at the parish church of St Mary. There is still a touch of the fairytale about a proper white wedding. Though one in three marriages ends in divorce, two don't. The institution is still popular and an occasion for joy as all concerned here confirm. Helen said: 'It was a very hot day, 16 May 1992, and a very happy occasion. I felt like a princess all day.' (*Dennis Sherer*)

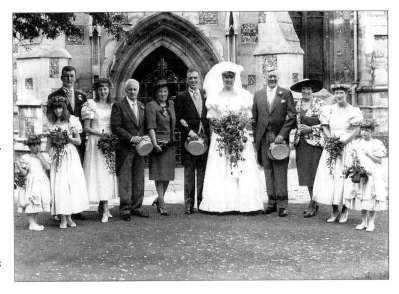

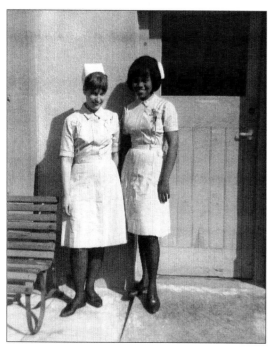

Pauline Donalds and a friend during training at Luton & Dunstable Hospitals in 1966. Training involved working at three local hospitals, taking your luggage each time you moved base. Pauline said she did not mind leaving her native Jamaica because she had always been very independent. Matrons were not the dragons portrayed by 1960s television, but she did not like the food. Young nurses had mentors, and if they stayed out late without a pass, they found it difficult to get past matron's office. Pauline said: 'My first pay packet was £30 per month. I thought I was rich. Food and accommodation were provided. You could get three bars of Lifebuoy for 2s 6d and two big packets of toothpaste for the same. You bought your winter coat but had to save up for an outfit. No credit cards then. About four of us did modelling for Buttons of Luton for a pittance, but it was nice to get to wear all those beautiful clothes. Some of the gowns were out of this world.' (*Pauline Hoyte*)

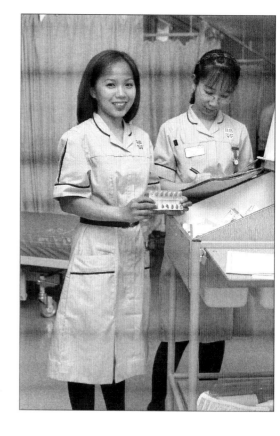

There is a great shortage of nurses today and 15 per cent of Luton's nurses come from the Philippines. Pauline Hoyte, née Donalds, says nursing has changed radically over the years. Hospital care has been reorganised on to one site, the Luton & Dunstable Hospital Trust. The hospital's website notes: 'It is hard to imagine the Luton & Dunstable 60 years ago with only 170 beds . . . built, equipped and maintained as a voluntary hospital for the first nine years . . . mainly as the result of the generosity of people who lived and worked in the district . . .' (*Luton & District Hospital Trust*)

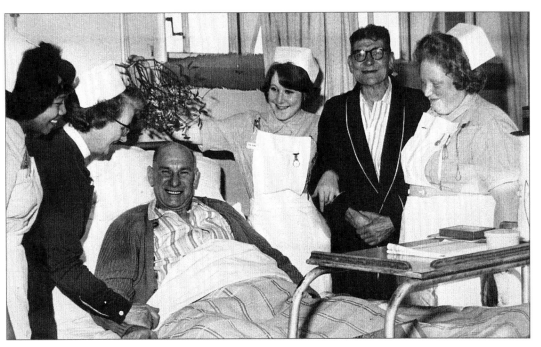

Nurses, matron and patients at Luton Hospital, *c.* 1967. Pauline Donalds, smiling, far left, would make anyone feel a bit better! (*Pauline Hoyte*)

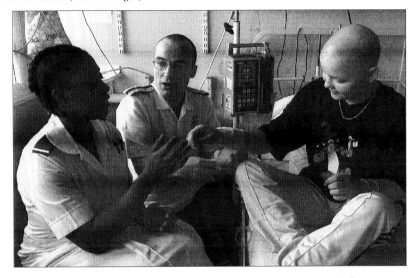

Luton & Dunstable Hospital today. Over £30 million of new building and refurbishment got under way in 2001–2, including a £2 million refurbishment of A&E. But none of this would count if it wasn't for the fine tradition of bedside care we see captured in this contemporary image. Pauline Donalds retired in November 2001. Looking back, she said: 'Technology has changed for the better, but nurses coming through today will not have the same hands-on sense that we had. Nowadays you just click a machine in the ear to take temperatures, or with blood pressure you just clamp on the equipment. That works all right in the cocoon of the hospital, but it is very technology dependent. Still, you have to move with the times.' (*Luton & District Hospital Trust*)

Webdale's ironmonger's and hardware shop, 21–7 Wellington Street, 1935. It served the town well, but was overtaken by changes in the nation's retailing style. (*Luton Museum Services*)

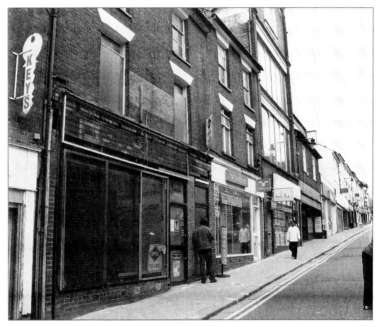

Webdale's shop today is a much changed location, and part of it is to let. Sadly, there seems to be no future in trying to revive Webdale's line of trade. (*Robert Cook*)

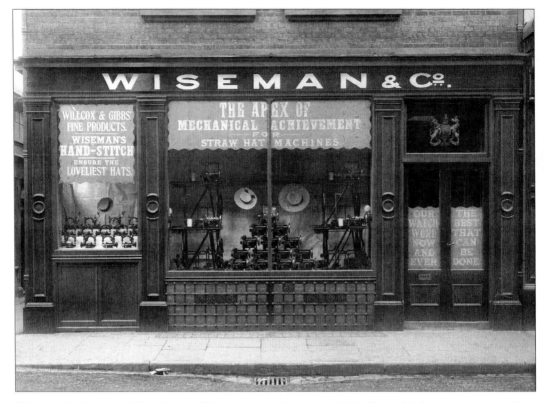

Wiseman & Co., at 1 Silver Street. This was one of many individually styled businesses in the hat-making district. (*Luton Museum Services*)

Wiseman's premises made way for the development you see here in Silver Street today. The style would have appeared a dramatic and perhaps exciting contrast at the time, but looking back some might hanker for the mystery and appeal of the old.
(*Robert Cook*)

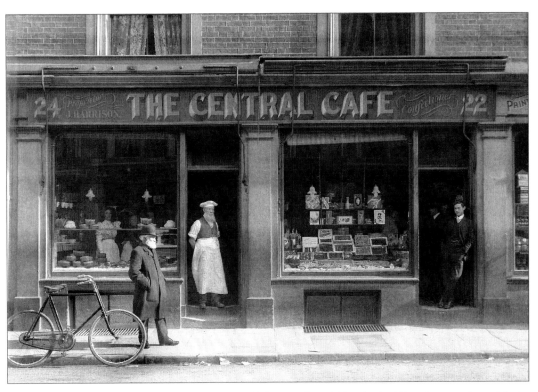

The Central Café at 22–4 Cheapside, 1907. It traded up to the 1950s, the building disappearing with the Arndale development. (*Luton Museum Services*)

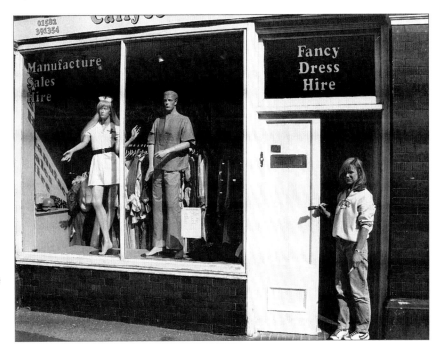

A few shops remain in the surviving part of Cheapside, including this interesting fancy dress hire shop. The relaxed lady proprietor contrasts with the apron-wearing gent of the previous picture. (*Robert Cook*)

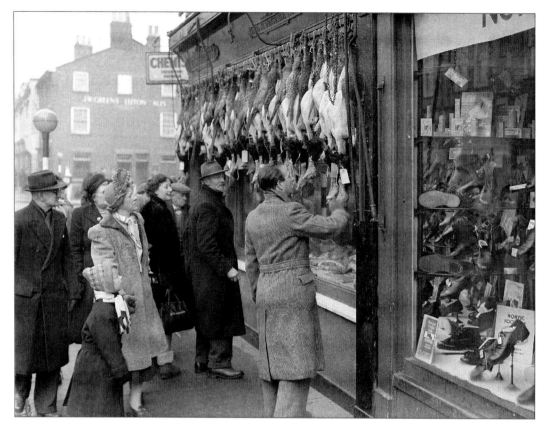

W.G. Durrant's butcher's shop at 32 Manchester Street, 1950. Christmas turkeys are displayed. Clearly the shop was very popular. Did anyone ever doubt it would always be there? (*Luton Museum Services*)

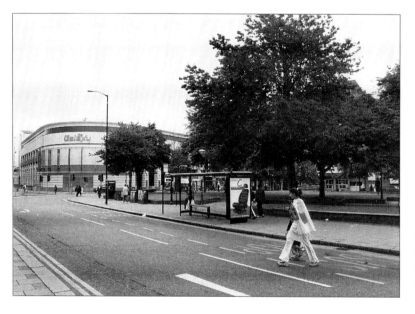

Manchester Street, 2002. The buildings on the north-east side of the street have gone to make way for a new traffic system and open space. (*Robert Cook*)

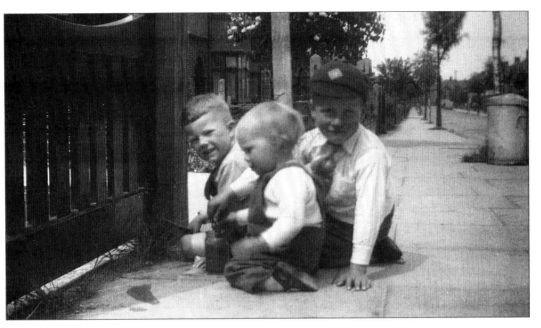

Wychwood Avenue, north of Wardown Park, early 1950s. Children could play safely in the quiet neighbourhood. The bin in the background contained waste food put out for the pig man. Britain was hard up after a hard war, the nation was still on rationing and little was left to waste. John Creasey, nearest to the fence, said, 'The bin also doubled as our cricket stumps.' (*John Creasey*)

Wychwood Avenue, July 2002. There are no children on the pavement, cars have taken over that favoured spot. Still, this is a homely little enclave, complete with trees and solid suburban-style dwellings. (*Robert Cook*)

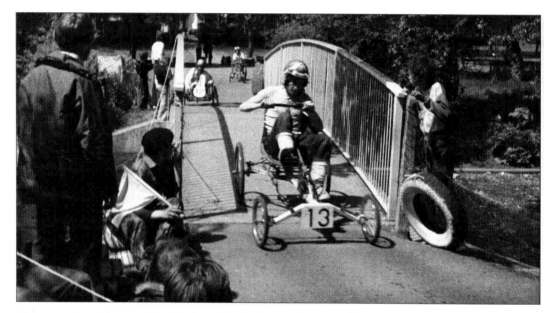

The annual pedal car rally, Wardown Park 1978. This was a competition for cars built by local apprentices from leading local firms such as Vauxhall, Kents, Marconi and Electrolux. (*Jane Creasey*)

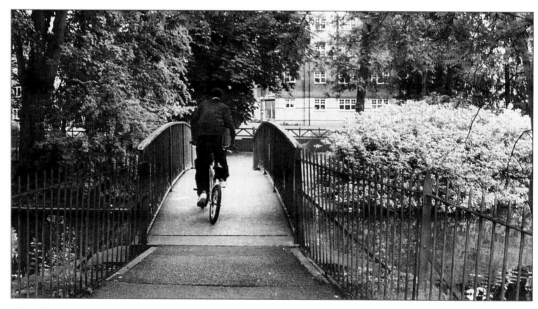

There have been a few changes to the bridge, probably to stop people falling into the river and suing the council! In this captured moment a young man is testing his cycling skills, speeding across the bridge in the direction of Old Bedford Road. The park is very popular on summer weekends, and very multicultural. Irishman and pensioner John Cheevers said: 'People from all sorts of different backgrounds live in Luton. They get on very well. They know they have to. There was a lot of prejudice against us Irish when I came here to work at Vauxhall's thirty-six years ago. Because of the troubles police were suspicious of us in the pubs. They bothered us so much, it got like you didn't want to go out in the end.' (*Robert Cook*)

The family back garden at Corncrake Close, with Jane Pilbeam captured on camera in a very fashionable pose, 1971. Luton was portrayed as a place to get out of in a television sitcom that made much of the town's motor industry associations. The 1970s were a curious period stylewise: peace, love, glam rock, and industrial strife gradually made way for Thatcher's materialism. (*Jane Creasey*)

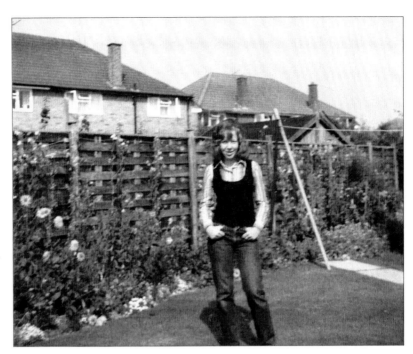

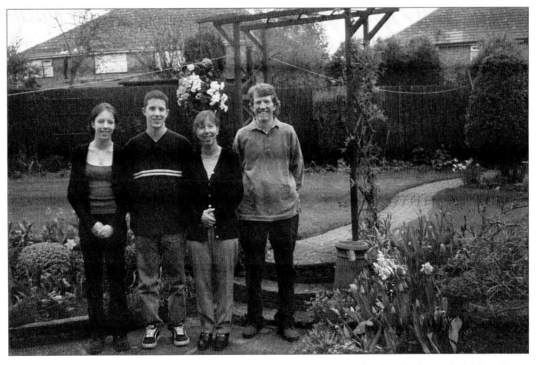

Jane Creasey, née Pilbeam, returns to her Corncrake Close home with husband John and children Sarah and Ben. Family life provides the continuity and bedrock for the future, though much praise is given to the alternatives. (*Jane Creasey*)

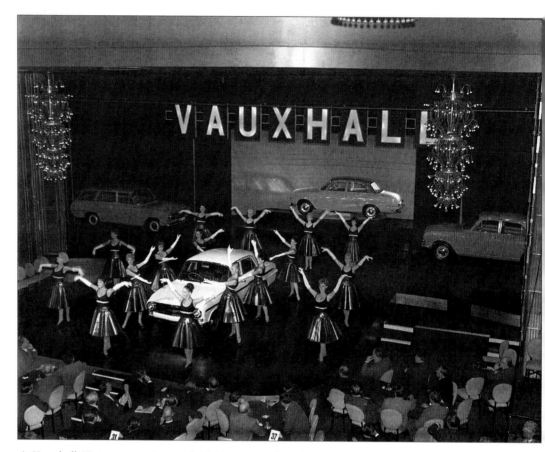

A Vauxhall Victor promotion, mid-1960s. Car styling has been, until recently, very male orientated. This picture records a time when men were men and women were what men wanted them to be. These glamorously dressed ladies are performing to the delight of an entirely male audience. Interestingly, attractive ladies are still used to promote car sales – I'm not complaining, but it is interesting! (*Vauxhall Motors*)

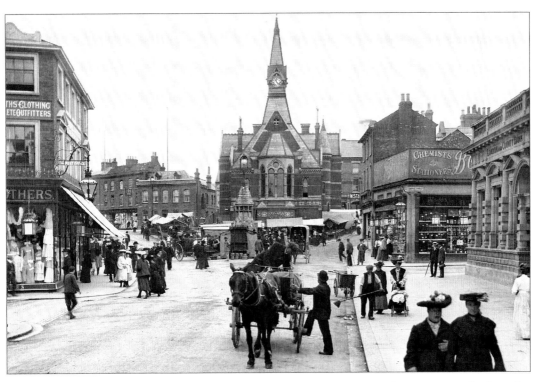

George Street looking towards the Corn Market, *c.* 1906. The old Boots store frontage protrudes far right, with Park Street extending left of the Corn Exchange and Castle Street to the right. The Corn Exchange opened on Market Hill in 1869 for corn chandlers; business was conducted by means of samples. (*Luton Museum Services*)

George Street looking in the same direction, July 2002. The Corn Exchange was demolished in 1951 for safety reasons. Fittingly, since the old building was used among other things for the manorial court, the replacement building is the Law Courts. The old Boots is now an estate agent. It has gained an upper level. (*Robert Cook*)

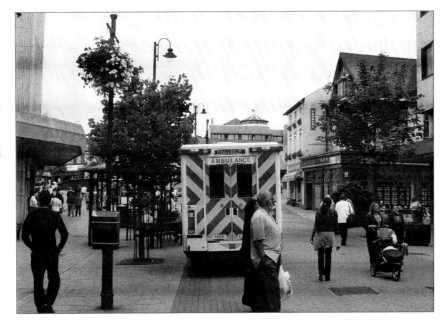

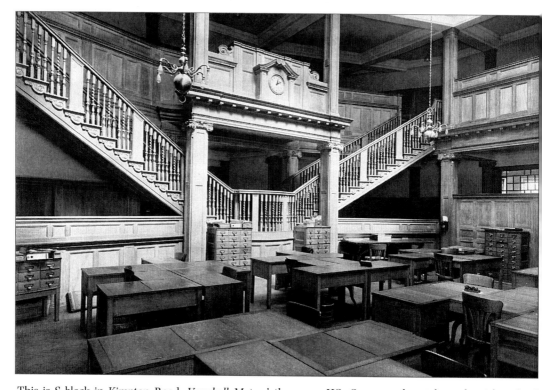

This is S block in Kimpton Road, *Vauxhall Motors*' then new HQ. One can almost hear the tick tock of the clock in this 1930s scene. The desks add to the charming atmosphere. There are no clerks but their ancient filing system is in evidence. When they finished for the day they would go out into a very different Luton to the one we see today. (*Vauxhall Motors*)

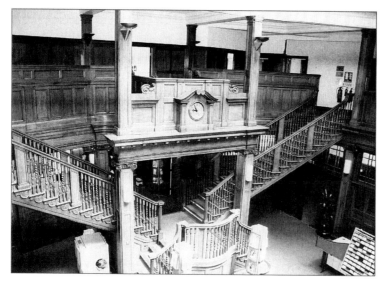

The scene appears to be little changed today in the caring hands of Chambers Business. One of the young staff says it's nice working in this old-style environment. She said it is better than the cold functional style of modern offices. There is little to show that the hands of the clock have completed thousands of circuits, except the photocopier and notice board. There is no doubt that the extensive use of English oak, with all the carvings and joinery, demonstrates Luton's tradition of craftsmanship at its best. (*Robert Cook*)

Vauxhall

Vauxhall Heritage Centre, Griffin House, 2002. The building houses a fine collection of historic Vauxhalls, all in the safe hands of two restorers, Dave Hinds and Andy Boddy, seen here with archivist Dennis Sherer. The Vauxhall Ironworks was founded by the Scottish engineer Alexander Wilson in 1857 in what developed as the Vauxhall district of London, where Falkes de Breauté had founded his fortune. Wilson took de Breauté's griffin (from his coat of arms) as his own, making it famous on the front of Vauxhalls worldwide. However, Wilson left the company before it began to specialise in cars following a move to Luton in 1905. (*Robert Cook*)

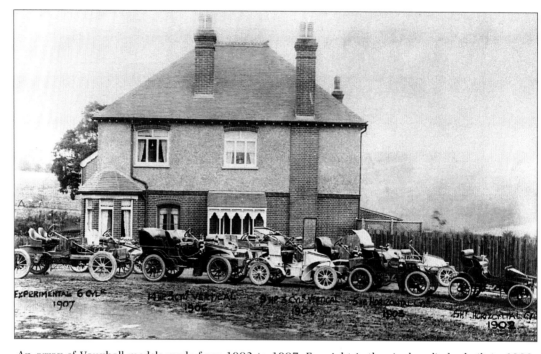

EXPERIMENTAL 6 CYLS 1907 14 HP 3 CYL VERTICAL 1906 9 HP 3 CYLS VERTICAL 1904 5 HP HORIZONTAL 1903 5HP HORIZONTAL CAR 1902

An array of Vauxhall models made from 1902 to 1907. Far right is the single-cylinder built in 1902, when the company was still specialising in marine steam engines. Moving to the left reveals the company's progress in design and technology. Extreme left is the experimental six-cylinder model. The first two models in the line were tiller steered. The house in the background was taken over as the first HQ in Kimpton Road. (*Vauxhall Motors*)

THE VAUXHALL IRONWORKS COMPANY, LIMITED.

INAUGURAL LUNCH IN THE NEW WORKS, LUTON, MARCH 29TH, 1905.

W. GARDNER, ESQ., MANAGING DIRECTOR IN THE CHAIR.

GENERAL VIEW OF THE WORKS AND ESTATE,
LUTON.

Kimpton Road at the time of the inaugural lunch, 29 March 1905. The works were developed behind the managing director and chairman's house, which is recognisable from the previous picture. We are looking east. (*Vauxhall Motors*)

The Vauxhall car factory from the plateau, looking west toward Luton, *c.* 1905. The managing director's house and a small terrace are visible on the right. (*Vauxhall Motors*)

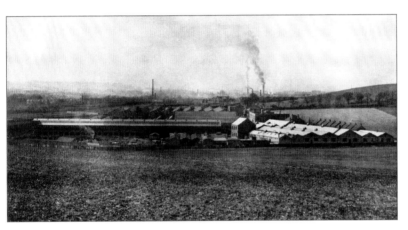

The Vauxhall car plant viewed from the same point in 1919. Development has been rapid, stimulated by the demands of the First World War. (*Vauxhall Motors*)

Today's view is obscured by a large warehouse built on land now surplus to Vauxhall's requirements. (*Robert Cook*)

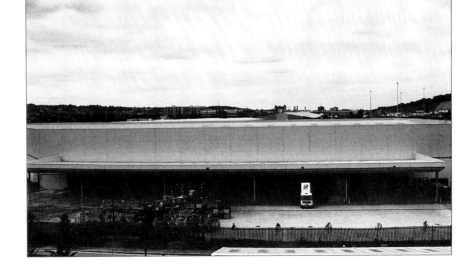

The years immediately following the First World War saw a decline in the old heavy industries, but motor building was fairly buoyant. America's General Motors redesigned their Chevrolet trucks for the British market and sought manufacturing capacity. Buying Vauxhall and moving to Luton was the solution. Consequently there was massive development of the site. This image shows F block under construction in 1934. (*Vauxhall Motors*)

In order to make the changes, the original Kimpton Road HQ and terrace, seen here, had to be demolished. The white sign in the centre reads Vauxhall Employment Office. (*Vauxhall Motors*)

The Griffin symbol still marks one of the main gates in Kimpton Road. The site of the old managing director's house lies just before the modern white building at the end of the original S block. Today it is the site of a large water storage tank. F block has been demolished. (*Robert Cook*)

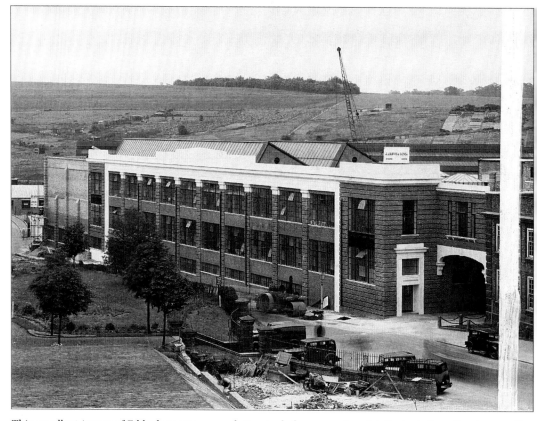

This excellent image of F block nearing completion includes many fine details, including the steam roller and hillside backdrop, in the days when Luton was very close to rural life. (*Vauxhall Motors*)

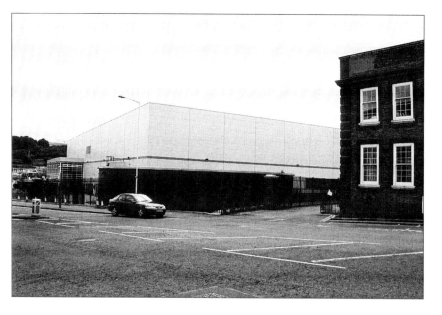

From an architectural viewpoint the scene today looks rather bland. The edge of S block is to the right, next to the big tank and a warehouse. (*Robert Cook*)

The new AA block dominating this 1950s scene was one of the largest steel-frame structures of the day. Bedford CA vans (parked in the foreground, right) were made by the commercial department, taking their divisional trademark from the county. (*Vauxhall Motors*)

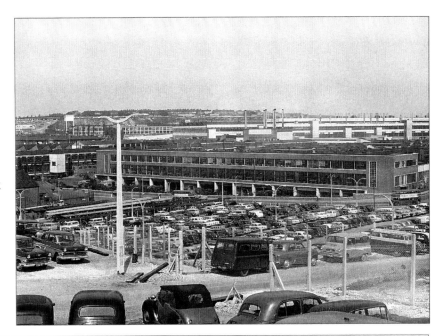

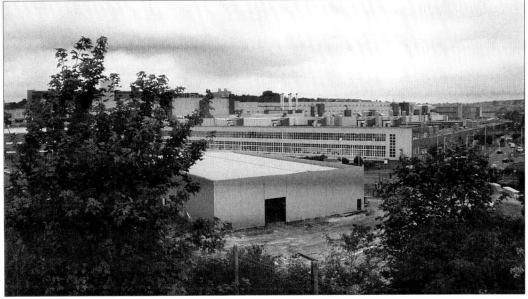

The same location, July 2002. Some change is apparent. There was shock in December 2000 when the press announced the forthcoming end of car production at Vauxhall, the company name having long been thought of as synonymous with Luton. Two thousand jobs were said to be at risk. In a world of overcapacity, it did not surprise industry specialists, but many workers felt a sense of being let down after years of loyalty. John Cheevers said the good thing about working for Vauxhall was that 'you were working for the Yanks; you could be sure of a good pension. I liked working at Vauxhall. Although it was shift work, there was a lot of camaraderie. There were also lots of nationalities but we learned to get along with each other.' Nowadays AA block survives as the plant for making Isuzu Bedford Commercial (IBC) vehicles, though the heavy truck division was sold off and closed down some years ago. (*Robert Cook*)

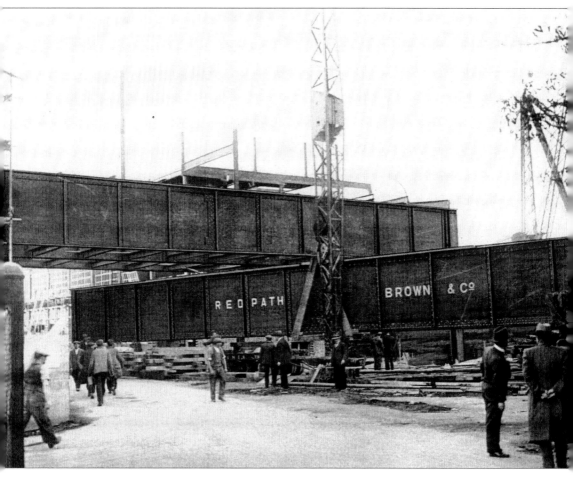

In 1934 Vauxhall announced that it would have to expand, either by crossing the railway line or Kimpton Road. The company chose the latter, using massive 45-ton girders, 92½ feet long and 9½ feet high, to build a bridge to connect the new and existing plants. The new building would overshadow all the others; assembly lines little short of half a mile would run the length of it. Those girders and construction work are shown here. (*Vauxhall Motors*)

Opposite: Vauxhall is a shrinking plant. Most of the original site buildings have gone or have been redeveloped. A new roundabout has been built for increasing light industrial traffic and the bridge is no more. (*Robert Cook*)

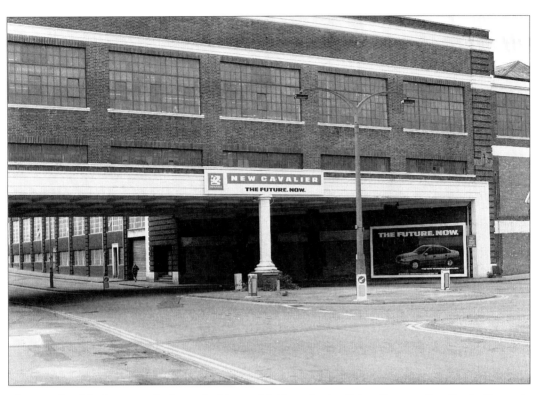

The completed bridge towards the end of its useful life and advertising the new Cavalier in the early 1980s. GM invested heavily during the 1980s, producing the front-wheel-drive Astra and launching the fifteen-model Cavalier range. Dealers from all around the UK drove 700 vehicles on launch day in 1981. A quarter of a million were sold by 1983. (*Vauxhall Motors*)

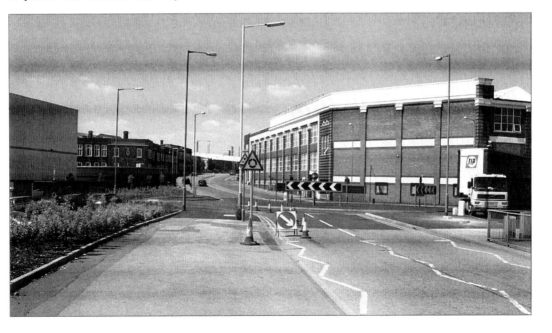

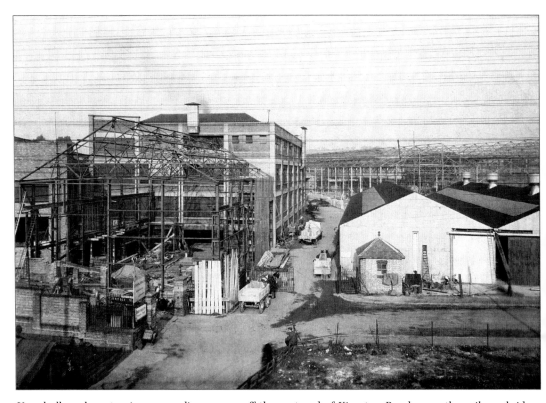

Vauxhall works extension proceeding apace, off the east end of Kimpton Road, near the railway bridge, 1950s. Real horsepower here makes an attractive contrast to modern diesel fumes. (*Vauxhall Motors*)

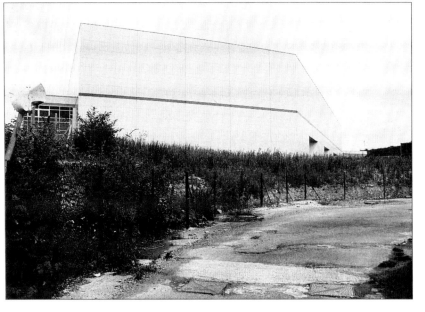

The same place today. Modern factory unit styling, using stark quick-build panels, contrasts with the remains of the old road seen in the previous picture. It's hard to imagine that time will make this image as interesting as the previous one. (*Robert Cook*)

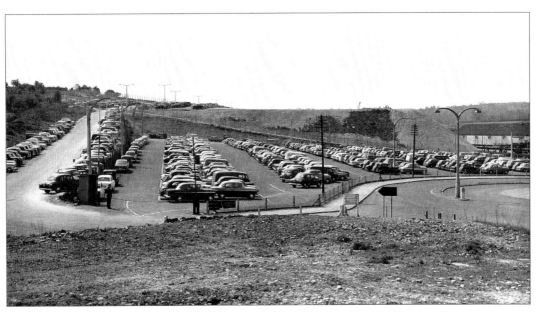

Kimpton Road and the Vauxhall factory can be glimpsed to the right, as the camera looks south toward Luton Hoo Park and Harpenden, 1960s. Spittlesea Road is just a lane running in front of the car park which contains almost entirely Vauxhall vehicles, though a Morris van looks rather conspicuous. (*Vauxhall Motors*)

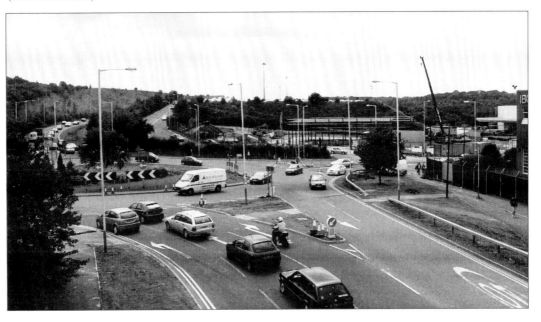

The hillside contour makes this contemporary view recognisably the same as the last, but there have been great changes, including the construction of Lower Harpenden Road. Spittlesea Road exits left from the roundabout and is now the main route to the busy airport. In the background, right, a motor dealer's premises rises on redundant Vauxhall land. Far right, we glimpse the letters IB (of IBC) on a building facing Airport Way. (*Robert Cook*)

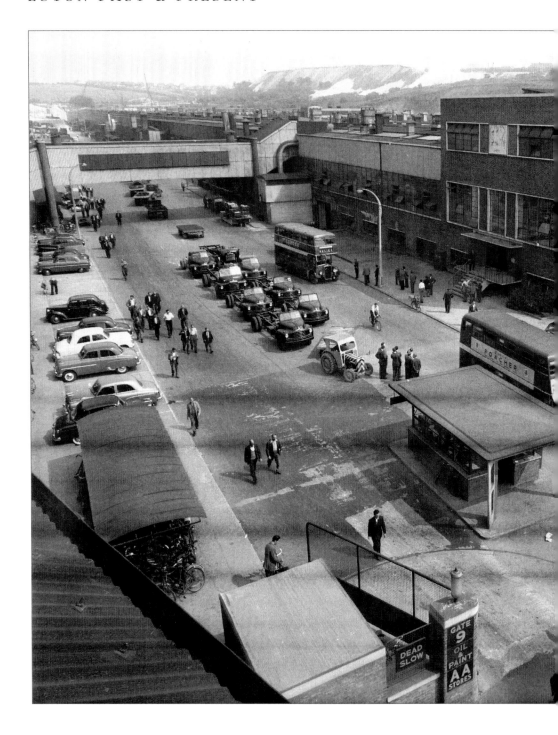

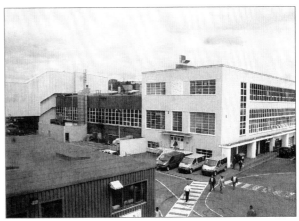

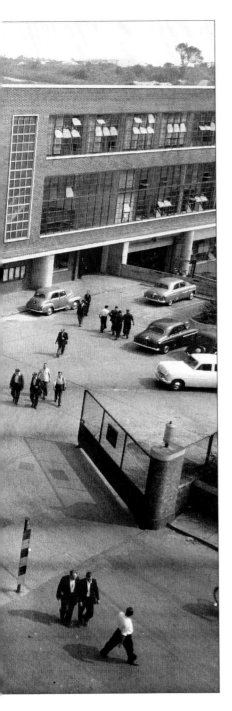

Main image: Vauxhall/Bedford AA block, Kimpton Road, 1950s. Workers have finished their shift. The block was erected as part of large-scale expansion during the 1950s. GM executives came over from the United States, enduring the privations of postwar Britain, to get production back to normal. Much of the company's success was down to long-serving designer David Jones and the L type 4-cylinder Wyvern and 6-cylinder Velox models. Most of the cars in this picture are Detroit-influenced E types, but an L type is parked by the pavement in front of the building. Unbodied Bedford trucks are parked in the access road. Summer heat is indicated by the Chilterns shining white in the background, and the bus drivers' cab windows are open. (*Vauxhall Motors*)

Above: The buildings of AA block look much the same, though they have been refaced. IBC now occupies the plant and examples of its vehicles are parked by the side of the building. Once again workers are coming off shift, but there are no longer queues of works buses because personnel have their own vehicles. Bedford Trucks disappeared during the 1980s, continuing for a short while as AWD, sustained by military contracts. Bedford trucks were the mainstay of the British Army from the Second World War until their demise. As in the car industry there has been overcapacity in Europe, and Scandinavia, once an importer of British vehicles, has become a competitive exporter – to the British industry's cost. The good news for Luton is that for the foreseeable future IBC's 3,500 employees will continue in work. (*Robert Cook*)

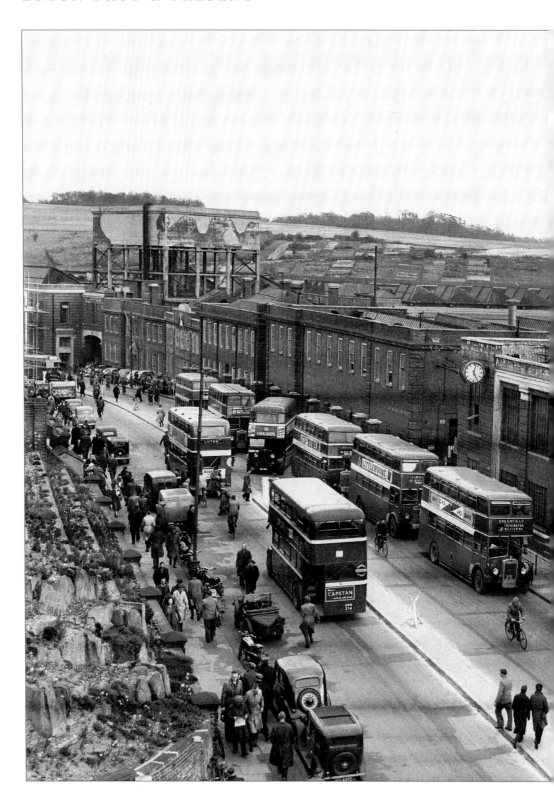

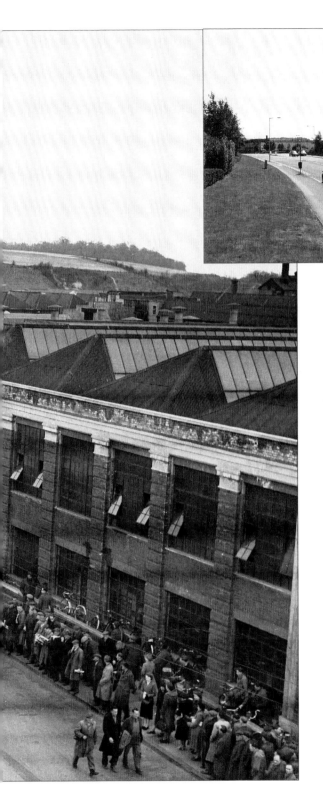

Main image: Kimpton Road, looking south-east, 1951. Workers are waiting for buses to take them home. The hillside rising above the roof line reminds us of the pretty countryside that surrounds the town. (*Vauxhall Motors*)

Above: The scene in Kimpton Road is barely recognisable today, except for S block, GM's purpose-built headquarters, just over the hill. Modern-style warehousing dominates the building line. Works buses, once provided by United Counties and the corporation, are no more, but a lone Arriva single-decker completes the comparison. (*Robert Cook*)

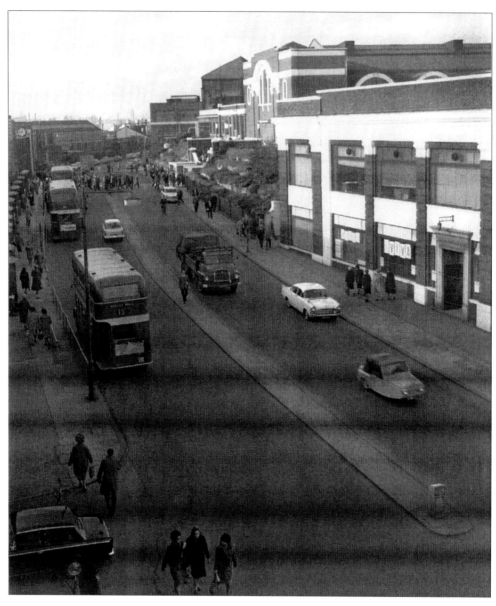

Kimpton Road viewed from S-block roof, looking north-west towards Wyvern House and the canteen. The little HA Viva car, bottom left, and promotional banner in the window of Wyvern House, dates this image to 1964. The government encouraged Vauxhall to establish a plant in an area of high unemployment. An old airfield was chosen at Hooton, on the south side of the River Mersey. The first Viva came off the line on 4 June 1964. This decision would have long-term implications for Luton; restructuring meant that production was to be concentrated at Ellesmere Port. This image shows us more of the workers' reliance on buses, though there are a few cars and also a locally built big Bedford S type, a GM-influenced design which appeared in the early 1950s. (*Vauxhall Motors*)

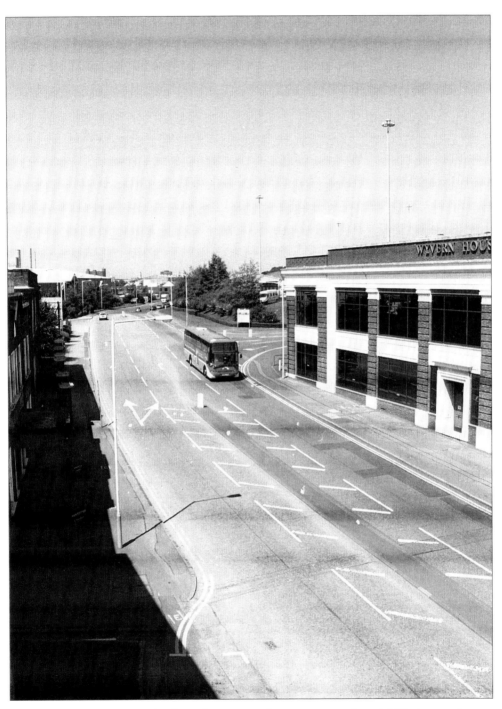

The scene is rather changed today. The canteen, home to so much social life, has made way for a new factory entrance and all the plant buildings on the left-hand side of the road (south-east side) have gone. A modern coach approaches Wyvern House, reminding us just how much coach and bus design has improved since the 1960s. (*Robert Cook*)

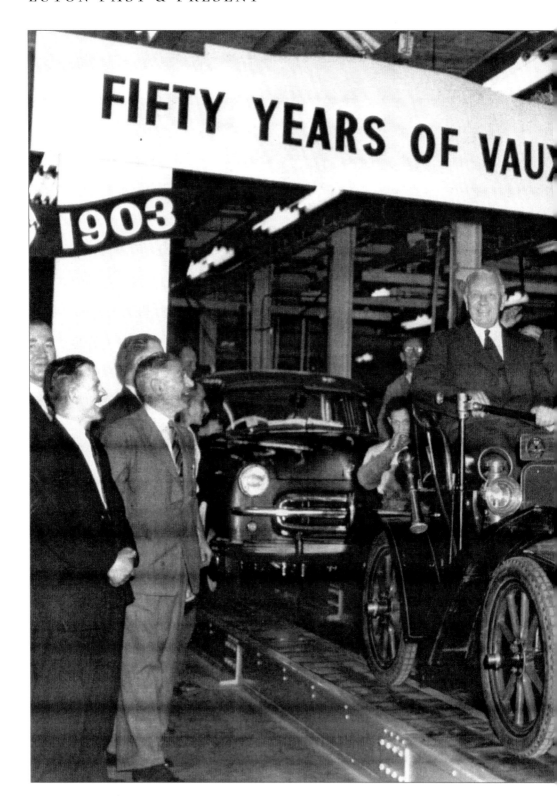

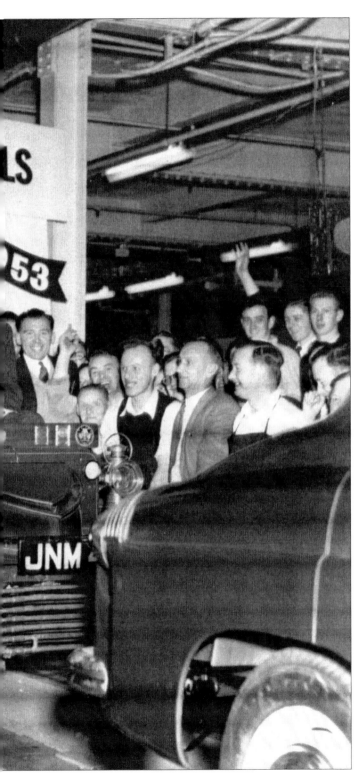

Company top brass enjoy celebrations of fifty years of car production in Luton, March 1953. They are riding the line in the company's first Luton-built vehicles, sandwiched between two of the Detroit-influenced E types. By this time the Luton plant had built a million vehicles, the Bedford A type had replaced K, M and O ranges, and the very successful Bedford CA 10/12 cwt van had been introduced. The £36 million plant expansion was announced the following year and the E type Cresta was launched. The man in the driving seat is Sir Charles Bartlett who became managing director in 1930 and held the post for twenty-three years (longer than anyone else). He became chairman in 1953 and retired in 1954. He instigated a father and son system of recruitment, a system known as the Vauxhall Family. He also introduced profit-sharing schemes and a management advisory committee to deal with shop-floor grievances. He was knighted in 1944 for his company's contribution to the war effort. Beside Bartlett is Walter E. Hill who became managing director in 1953. (*Vauxhall Motors*)

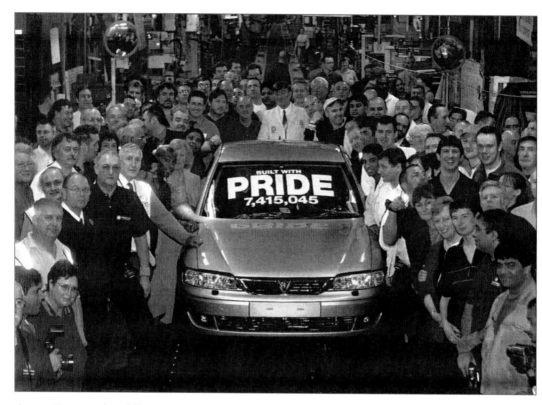

A new Vectra with a difference: it was the last car to roll off the Luton production line in March 2002. Proud workers surround the line. Anger had been expressed around the town against global capitalists who were careless about decisions affecting many people's lives. Perhaps it had been forgotten that without global capitalism the company and the area would not have enjoyed such prosperity for so long. Owners GM had to view the wider picture. TGWU leader Bill Morris blamed lax domestic laws which made it easier to lay off British workers than foreign ones, accusing Vauxhall of cynical disregard for the workforce. However, GM also laid off 2,000 workers in Germany. Vauxhall chairman Nick Reilly had previously warned the government that there could be millions of British job losses if the country remained outside the Euro. (*Vauxhall Motors*)

Luton First

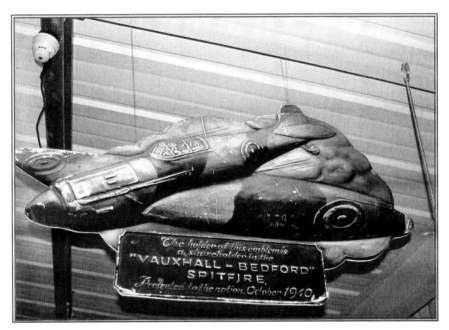

Life will always have its struggles. This plaque at the Vauxhall Heritage Centre recalls fund-raising efforts for the Vauxhall Bedford Spitfire during the nation's greatest struggle to date. Luton still has its battles to win. There are all the inevitable problems a large town can face, housing and employment being among them. But for all the anxieties about not having joined the Eurozone, the fact is that Britain is attracting more foreign investment than any of those inside it – according to the government agency Invest UK's 10 July 2002 figures. There is no reason why Luton cannot share in this prosperity, and Luton First exists to promote this. Of course, prosperity isn't everything and there are many who lament the declining sense of community as Luton has grown. Prosperity can also encourage crimes, such as the mugging of a blind pensioner in Argyll Avenue, crimes that are often drug-related. But these problems afflict the nation. (*Vauxhall Motors*)

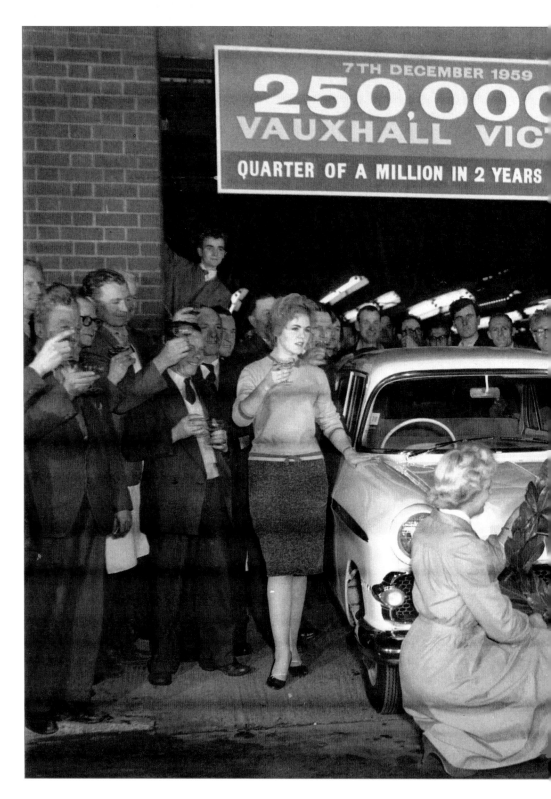

The 250,000th Vauxhall Victor rolls off the production line on 7 December 1959, a remarkable tally in under three years. This picture symbolises what the town has achieved. Who knows what great things lie in store for the future? It's a matter of the common will to succeed. It's up to the people. Vauxhall has been a leading influence on Luton and has adopted a caring attitude to employees. Before the Welfare State was created in the late 1940s the company launched a rehabilitation unit to help workers cope with injury and disability, even if their health problems were not the result of a work accident. Guided by Luton & District Hospital consultant Laurence Phewes, workers were given production tasks designed to suit their disability. (*Vauxhall Motors*)

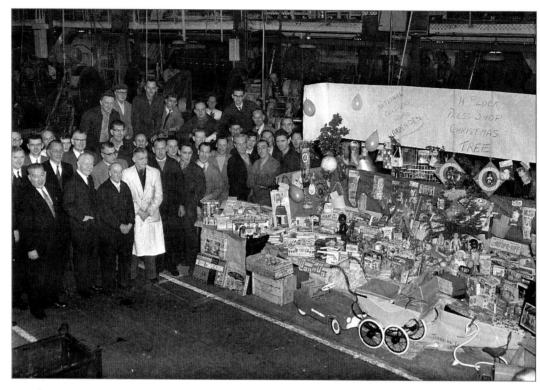

People Power, Christmas 1957, with toys collected by Vauxhall workers at H Block press shop. These are for the National Children's Home in Harpenden. (*Vauxhall Motors*)

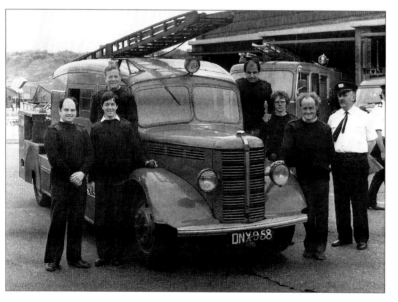

This fire engine became the focus of people power in 2002, appearing as a wreck in the TV series *Salvage Squad*. The Rover car company had owned it but when it became surplus to requirements the Luton-built vehicle was given back to Vauxhall, and was photographed here at the factory fire station in June 1981. Vauxhall passed it on to a museum where it was neglected. It became a subject for the renovation series in 2002 and is now a museum piece. (*Vauxhall Motors*)

Luton Hoo during the 1980s, being used to promote Vauxhall cars and Bedford trucks and buses. Luton Hoo house was built to Robert Adam's design. Capability Brown established the gardens, damming streams to create lakes in front of the main rooms. The house took its name from Thomas Hoo, Speaker of the House of Commons in 1376. The Napiers, then the Earls of Bute, took over the property. The house was redesigned by Sir Robert Smirke following a serious fire. Sir Julius Wernher and Lady Zia were probably the most famous occupants, attracting royalty among their visitors. Audrey Wash recalls that her father was chef at the George Hotel when the Prince of Wales, later to become Edward VIII, called in late after visiting the Wernhers. Everything was closed up and all the chef had was liver and bacon. 'Afterwards he complimented my father, saying that it made a change to have some plain fare. He was used to being given only the fanciest of meals!' The Hoo was later occupied by David Cola of Luton Town FC, and more recently a Canadian millionaire with so far unfulfilled plans to make it into an hotel. (*Vauxhall Motors*)

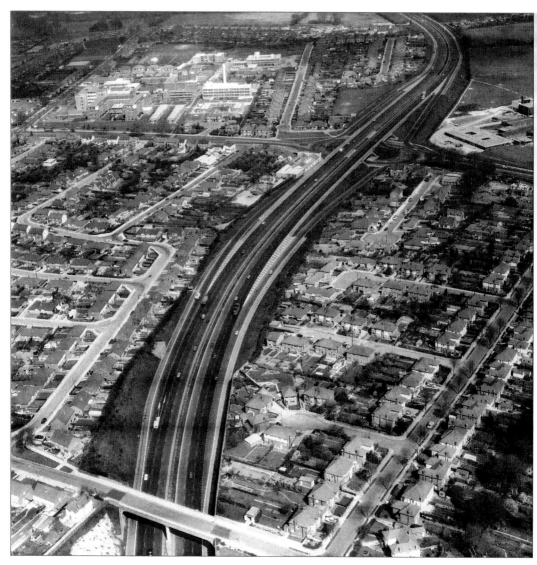

Luton was one of the first towns to be connected to the capital by the M1 motorway. This picture was taken in 1971, with junction 11 and the Luton & Dunstable Hospital towards the top of the scene. Halfway Avenue, Derby Road and Bradley Road are landmarks at the bottom of the picture. John Creasey remembers the motorway being built close to the bottom of his family's garden, and going with his friend for a long bike ride along it the night before it opened. That must have been another first. Not many can have cycled along the M1 and lived to tell the tale! (*Simmons Aerofilms*)

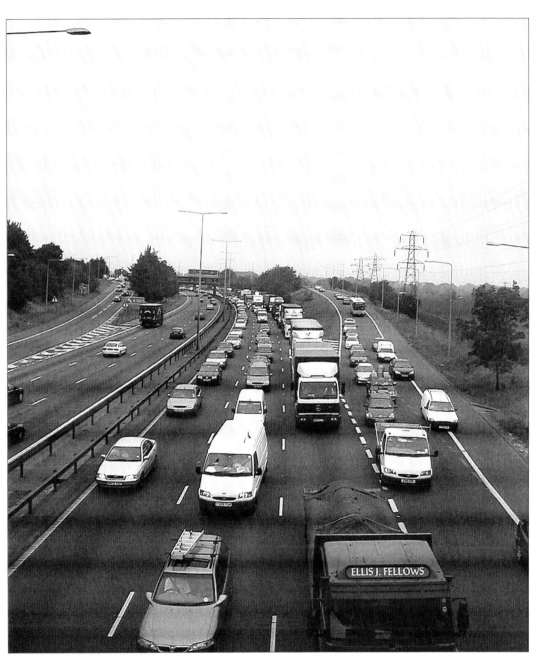

August Bank Holiday traffic crawling towards the capital near junction 10 of the M1, 2002. This is a world away from the carefree motoring conjured up by the picture on p. 108. (*Dennis Sherer*)

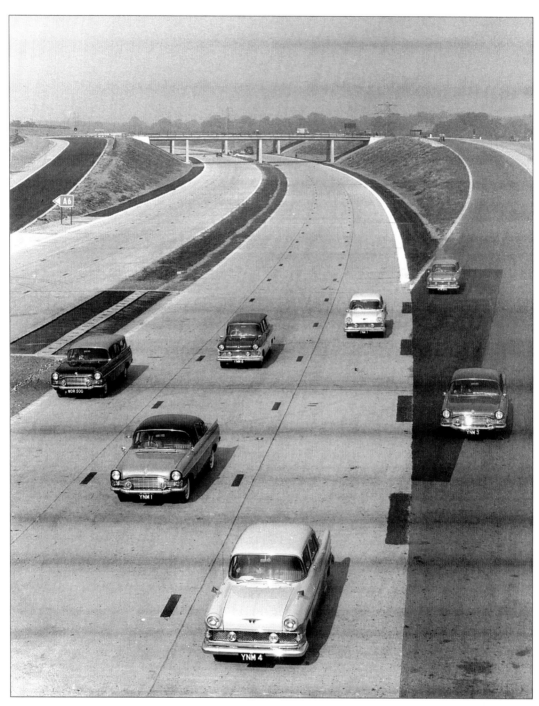

John Creasey wasn't the only local to do a first on the M1. This fine promotional display of new Vauxhalls at junction 10 is being used to identify the model with the new promise of the open road. As Brian Griffiths observed, 'We all expected it to be an easy route but it hasn't turned out that way. It is often jammed up.' (*Simmons Aerofilms*)

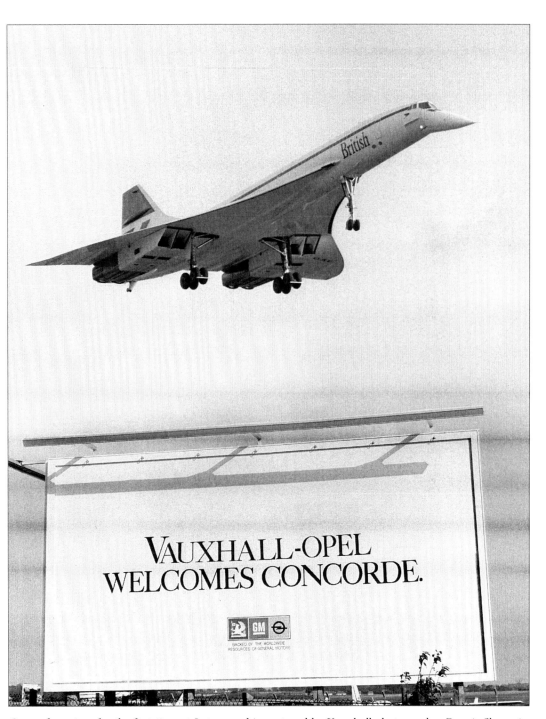

Concorde arrives for the first time at Luton, and is captured by Vauxhall photographer Dennis Sherer in all its beauty. The event was sponsored by Vauxhall. (*Vauxhall Motors*)

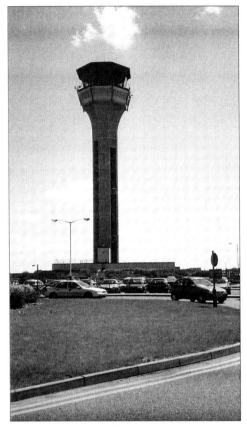

Above: The modern control tower is the tallest in the UK. It is a vital development because 6.2 million people use the terminal yearly, and fifty tour operators. The central terminal was refurbished in 2000. Demand for air travel is growing, and Luton is proposing new flight paths, causing concern in some Aylesbury Vale villages. There are worries about rising noise pollution, with 98 decibels on each take-off and landing. There is also the air pollution issue: worldwide, air travel creates 600 million tons of carbon dioxide annually. (*Robert Cook*)

Left: Luton Airport control tower, early 1960s. It was built in 1950. The scrabble-type slot board in front of the controller was used to log flights in and out; all was done manually. (*Vauxhall Motors*)

An instructor swings the propeller on this little de Havilland trainer, getting ready for take-off, Luton Airport, *c.* 1960. (*Vauxhall Motors*)

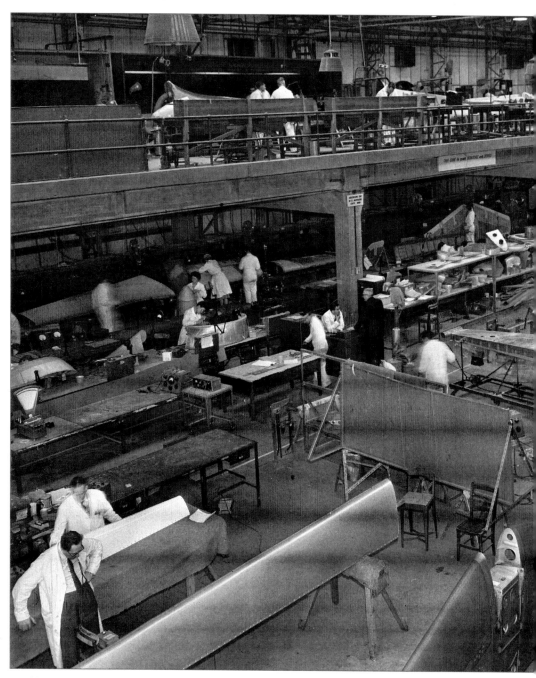

World wars stimulated aviation advances. Napier's, at Luton Airport, had a facility serving this end, seen here in the 1950s. The company was involved in pioneering de-icing systems on aircraft wings. (*E. Griffiths*)

Above: Frank Pilbeam, left, one of Napier's boffins, at work on the de-icing project. Napier's also played a part in developing the powerful diesel electric rail loco, helping to displace steam power on the railway. (*E. Griffiths*)

Below: The Napier site is occupied by Britannia Airways and Signature Flight Support today. (*Robert Cook*)

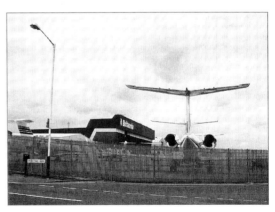

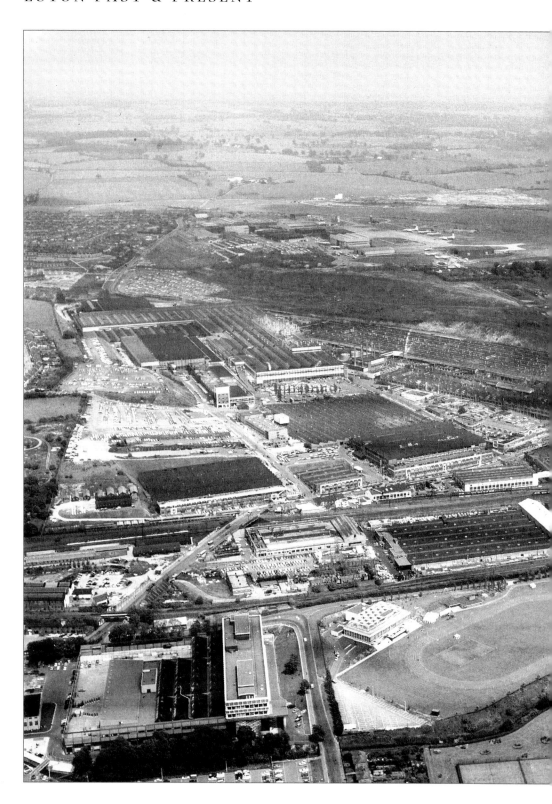

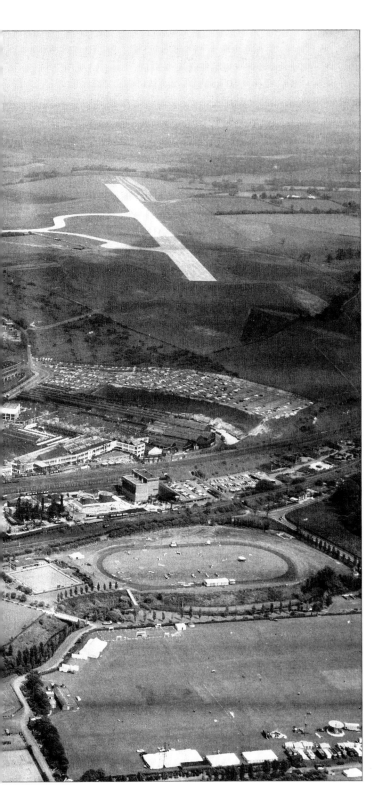

A grandstand view over Vauxhall and Luton to the east, early 1960s. The white concrete stripe of the runway points to the horizon. Luton Borough Council is a major airport shareholder and the airport has its own dedicated rail station at Parkway. (*Vauxhall Motors*)

Eaton Green Road, *c.* 1959. When the photograph was taken this was the main airport approach road. The hillside reveals work on excavations for the AC block expansion programme. (*Vauxhall Motors*)

Eaton Green Road, July 2002. Considerable development has taken place on both sides of the road. (*Robert Cook*)

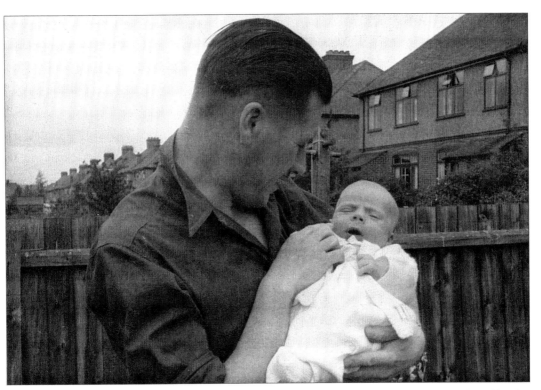

Sid Creasey in Wychwood Road with his young son, late 1940s. To many of us, there is nothing like the pleasure of having a new baby in the house, watching it grow, perhaps with increasing anxiety as to how it will prosper in an uncertain world. (*John Creasey*)

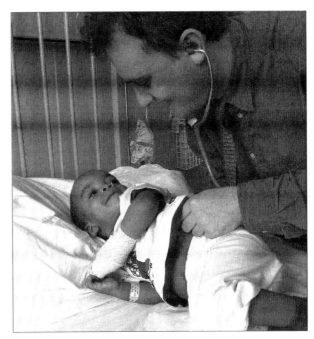

There are few certainties about child care, but it helps if you are as lucky as this little one, safe in the hands of a Luton & Dunstable paediatrician in today's modern baby unit. (*Luton & Dunstable Hospital Trust*)

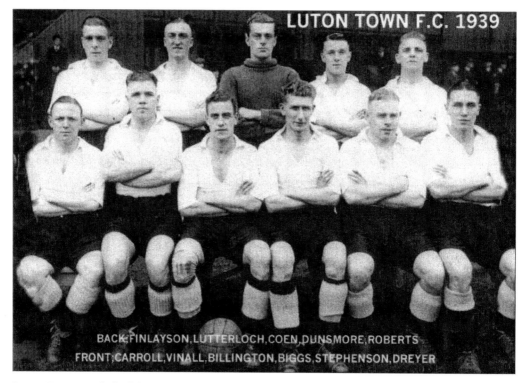

LUTON TOWN F.C. 1939

BACK: FINLAYSON, LUTTERLOCH, COEN, DUNSMORE, ROBERTS
FRONT: CARROLL, VINALL, BILLINGTON, BIGGS, STEPHENSON, DREYER

Luton Town Football Club, 1939. Joe Payne was a top scorer and football was not about glamour, more about simple working-class entertainment. (*Author's Collection*)

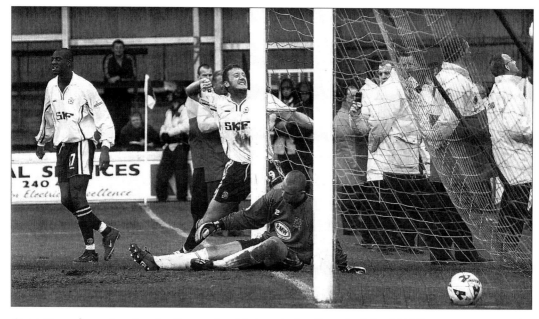

Steve Howard punches the air after scoring his twenty-fourth goal of the 2001/2 season. He won the golden boot and Luton were promoted. (*Andy Handley*)

Skipper Gary Waddock returns from injury. The modern player would not be complete without a message from the sponsors! (*Andy Handley*)

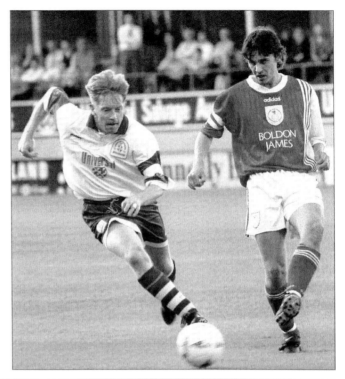

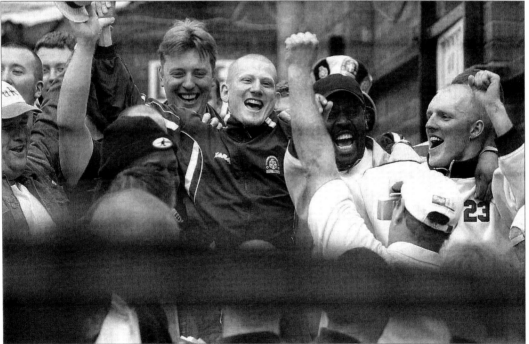

Fans lift skipper Kevin Nicholls during promotion celebrations after the last game of the 2001/2 season. (*Andy Handley*)

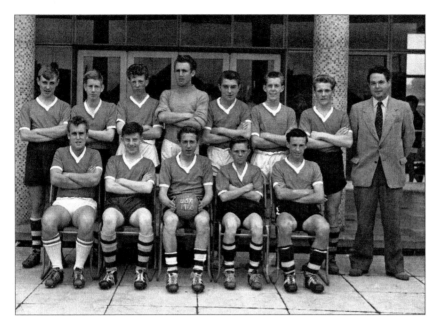

Barnfield Avenue Technical School football team, c. 1959. The future of British football starts in school. John Creasey is standing third from the left. (*John Creasey*)

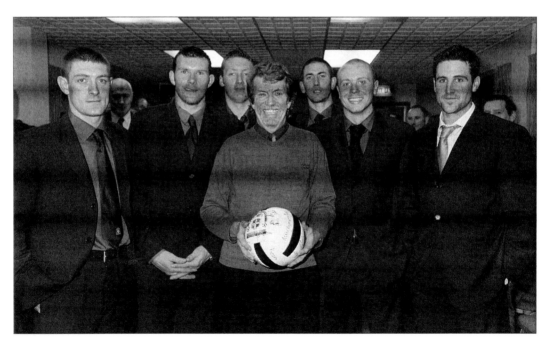

John Creasey and players, left to right: Coyne, Hughes, Perrett, Howard, Ovendale and Bayliss. This picture was taken after a match between Luton Town and Kidderminster on 16 March 2002. John won the ball, having made the nearest guess as to the size of the crowd. He's had plenty of practice, having been a supporter since the age of seven. He attended the FA Cup final against Nottingham Forest in 1959 and nowadays he occasionally sponsors a match. The club was promoted at the end of the 2001/2 season and has ambitions to move forward. (*Luton Town FC*)

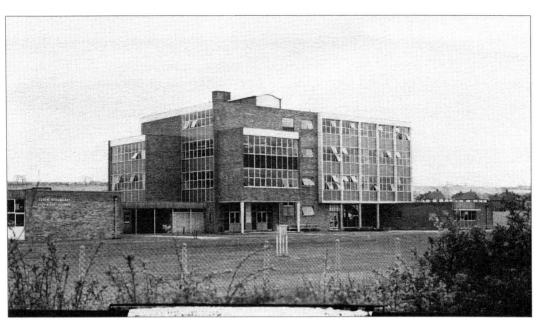

Barnfield Technical School from New Bedford Road, 1959. This image captures the nation's and town's optimism that education marked the way ahead. (*John Creasey*)

At the same place today the renamed Barnfield College is hidden by the trees. Barnfield College of Further Education helps provide training for jobs in Luton. The town has twelve high schools. (*Robert Cook*)

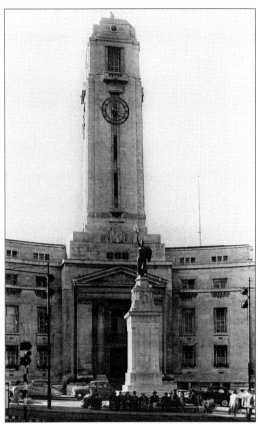

Luton's second Town Hall, built in 1936, with a sedate gathering and some elegant cars parked in the foreground, conveying the spirit of the 1950s. Post-empire, the country was looking towards an uncertain future, as Britain was nearly bankrupt. (*Author's Collection*)

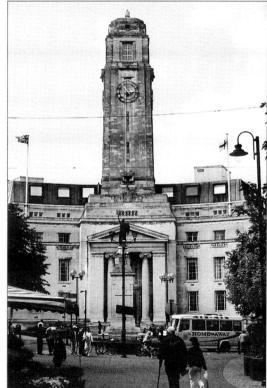

Luton Town Hall today. Today's people convey a perfect image of multicultural Britain at its best. (*Robert Cook*)

124

Acknowledgements

I would like to thank all those people who took time to talk to me about this project, including John Pilgrim on local radio who did his best to help get my research started via BBC 3 Counties Radio. Dennis Sherer at Vauxhall Motors archives went out of his way to help, and the book owes a great deal to his efforts and enthusiasm. I would also like to thank John Buttle and Luton Town FC, Helen Chadwick, John Cheevers, John and Jane Creasey for their invaluable guidance, Betty Davis, Kenneth Davis, Peter Davis, Freda Eastlake, Sally Farrish and Chamber Business, Chris Grabham at Luton Museum Services, Brian and Ena Griffiths, Andy Handley, Pauline Hoyte, Initial Photographics, Inland Revenue (Luton), Luton & Dunstable Hospital Trust, *Luton News*, Brian Mays and Luton First, A. Scarsbrook, Andrew Shouler, Colin Stacey, Vauxhall Motors, Audrey Wash, Roger Wash, Edwin Wilmshurst. Final thanks to Simmons Aerofilms for access to their fine archive. All efforts have been made to trace all copyright holders.

Over Eighty Years of Aerial Excellence

Aerofilms was founded in 1919 and over the years has built up a formidable commercial library of over 2½ million images. The major part of the collection comprises UK photography including historic black and white and modern colour photographs. The library includes both vertical survey and oblique photography. Oblique photographs, taken from the side of the aircraft, are ideal for displays, publishing and educational uses. Amongst the unique oblique images are aerial views of Crystal Palace before its destruction in 1937, and the airship R-101 on its maiden flight in 1929. Aerofilms' pre-eminence in this field allowed it to take over several of its rivals. Today, the negatives of Aero Pictorial Ltd (1934–66) and Airviews of Manchester (1947–92) form part of the extensive Aerofilms oblique library.

In 1987, Aerofilms took over the business of its sister company Hunting Surveys Ltd, which had specialised in vertical survey photography from 1946 onwards. As a result, Aerofilms' library of vertical photographs spans from the late 1940s to date, including county surveys and more specialised low-level surveys of coastlines and rivers. Vertical photography is an essential tool in the fields of mapping and surveying, and is widely used in the resolution of land-related legal disputes.

Simmons Aerofilms is currently undertaking a project to provide complete aerial photographic coverage of England for the twenty-first century. The Map Accurate Photographic Survey (MAPS®) by UK Perspectives will be captured at 1:10,000 scale and produced digitally to mapping specification to become the definitive base line data set for the U.K.

All photography is available as photographic prints or scanned as digital files on CD-Rom. Details of specific areas of interest can be faxed or posted to our Library and a free search will be carried out for relevant views. For clients with exact specifications Simmons Aerofilms can be commissioned to take new oblique or vertical photography at competitive prices.

Simmons Aerofilms

Gate Studios, Station Road, Borehamwood, Hertfordshire WD6 1EJ
Phone: 0208 207 0666 · Fax: 0208 207 5433 · E-Mail: library@aerofilms.com

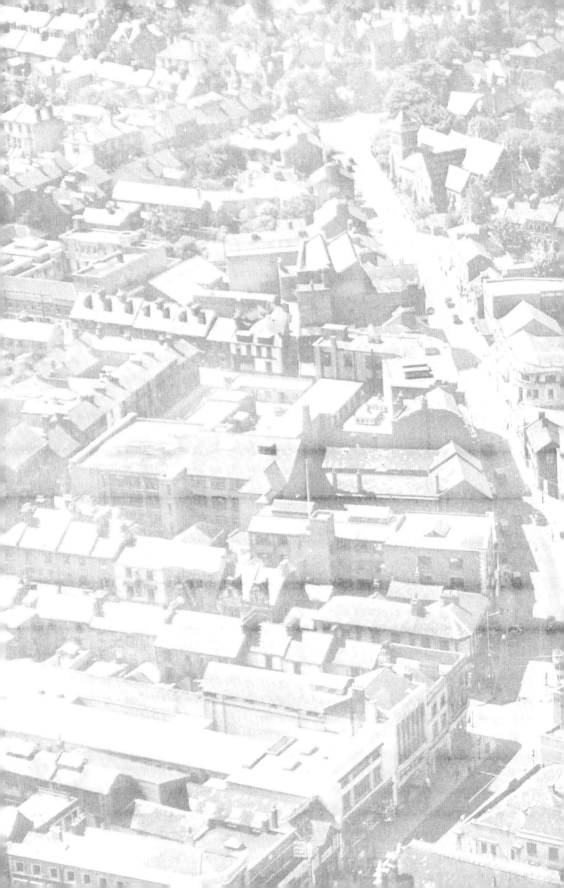

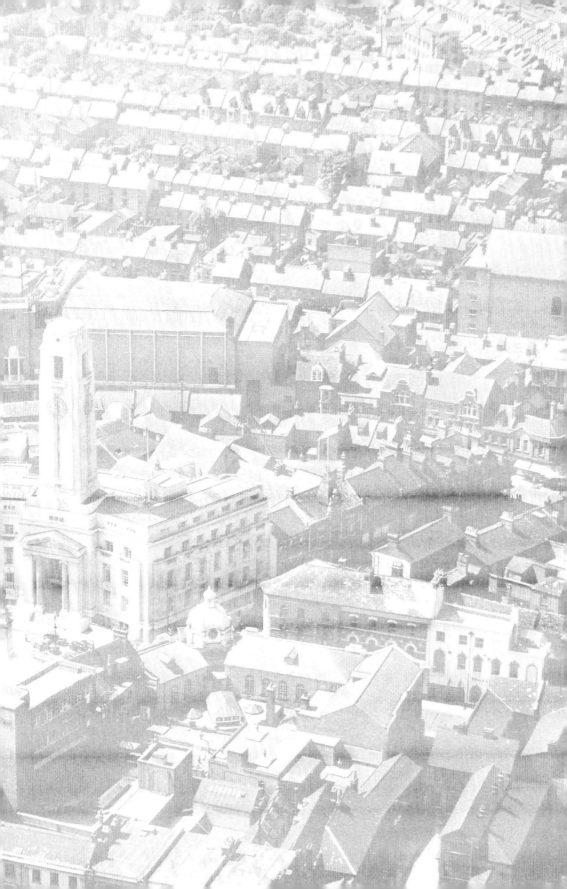